AUNG SAN SUU KYI

A PORTRAIT IN WORDS AND PICTURES BY CHRISTOPHE LOVINY

AUNG SAN SUU KYI
A PORTRAIT IN WORDS AND PICTURES

BY CHRISTOPHE LOVINY

WITH PYAY KYAW MYINT

MINZAYAR

AUNG PYAE

LYNN BO BO

SOE THAN WIN

hardie grant books
MELBOURNE · LONDON

SBS

in association with PQ Blackwell

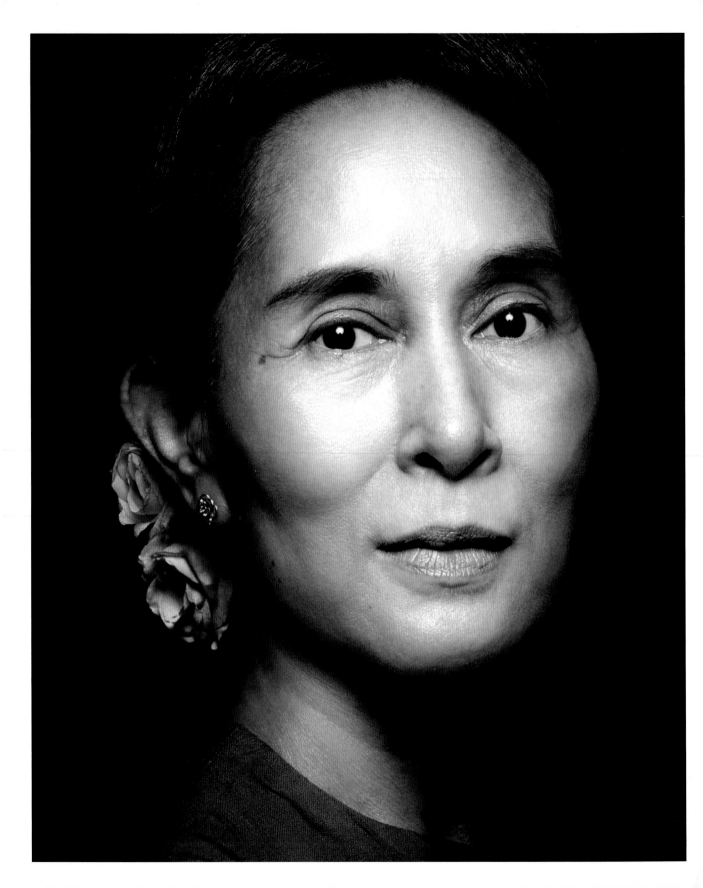

The only real prison is fear, and the only real freedom is freedom from fear.

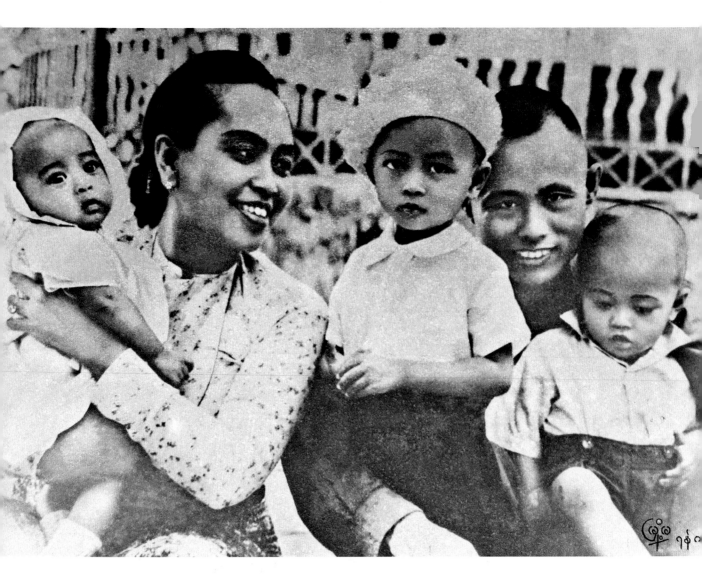

Aung San Suu Kyi was born on 19 June 1945 in Rangoon, the capital of Burma at the time, not long after it was liberated from the Japanese by the Allies. Suu's father, General Aung San, was Burma's greatest hero – he had founded the Burmese Army in 1941 and was negotiating with the British for independence. The image above shows Suu's family in the year she was born. She is held by her mother, Daw Khin Kyi, while her two brothers, Aung San Oo and Aung San Lin, jostle for space on their father's lap.

1945

1940 1950 1960 1970

I have a memory of him picking me up every time he came home from work, but I think this may be a memory that was reinforced by people repeating it to me all the time.

When I was ten or eleven I wanted to enter the army . . . Everyone referred to my father as *Bogyoke*, which means general, so I wanted to be a general too because I thought this was the best way to serve one's country.

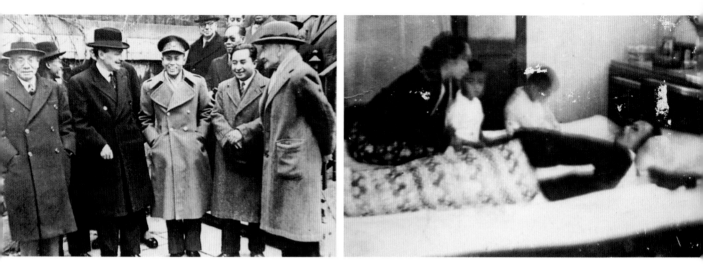

In January 1947, General Aung Sang led a delegation to England to discuss Burma's independence with the government. In the image above, he appears centre, while Prime Minister Clement Attlee is on his right. An agreement was signed between them on 27 January that guaranteed Burma's independence within a year.

Only six months later, however, General Aung San was assassinated along with eight others, including six cabinet ministers. Suu was only two years old. The image second from the left shows her brothers and mother alongside Aung Sang's body. The country mourned his passing, with huge numbers attending his funeral procession, as seen in the images on the facing page. A mausoleum was erected at the foot of the Shwedagon Pagoda in Rangoon to commemorate the deaths of General Aung San and the other officials, and 19 July, the day of the assassination, was designated Martyrs' Day, a national day of remembrance.

I was very proud of him and looked up to him not just as my father but as a great hero of our country.

1947

1940 1950 1960 1970

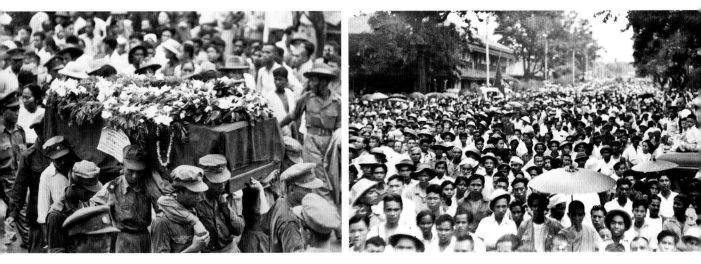

A man who put the interests of the country before his own
needs, who remained poor and unassuming at the height of his
power, who accepted the responsibilities of leadership without
hankering after the privileges, and who, for all his political
acumen and powers of statecraft, retained at the core of
his being a deep simplicity.

My mother was a very strong person . . . She was very strict at times, highly disciplined, everything at the right time, in the right way. She was a perfectionist . . . When I was younger I felt it was a disadvantage, but now I think it was a good thing because it set me up well in life.

It was my mother who was the head of the household, and as far as I could see . . . she could do anything that men could do.

1948

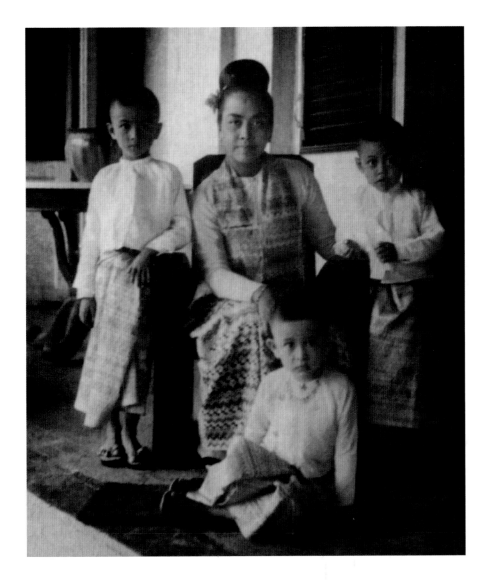

In the absence of their father, the world of Suu (seated at her mother's feet), Oo (standing left) and Lin (standing right) was shaped by their mother. Most children at that time were told to sit up straight at the table, but Daw Khin Kyi would not even allow her children's backs to touch the chair. Suu developed the upright posture that the world has become so familiar with. But more importantly, her mother instilled in her the values that would determine her actions in the future: honesty, purity, courage and compassion.

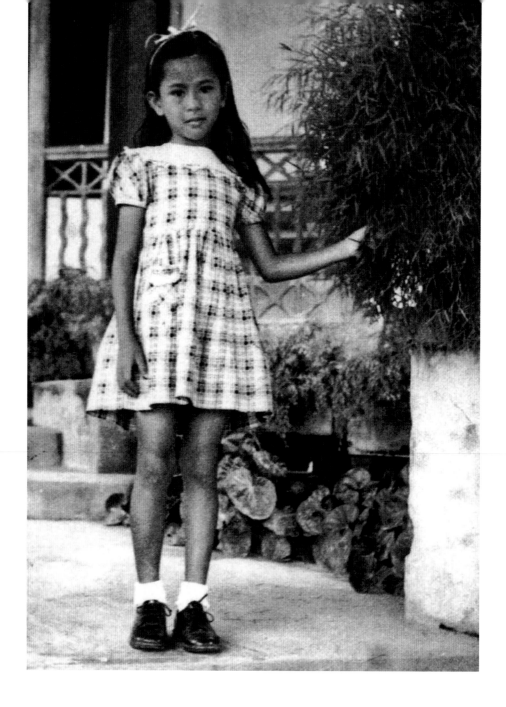

I was a normal, naughty child, doing things that I was told not to do, or not doing things that I was supposed to do . . . I preferred to play all the time. But I always knew when I was not doing what I should be doing.

1951

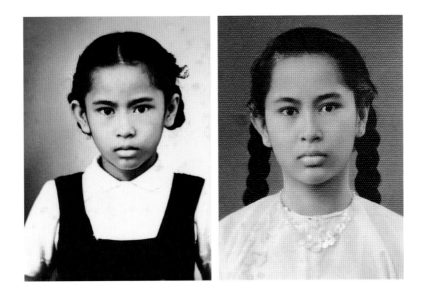

As a child, Suu attended St Francis Catholic Girls School. She had a very close relationship with her brother Lin and was grief-stricken when he drowned in a large ornamental pond next to the house. He was eight years old.

Suu subsequently attended the English Methodist High School, a private institution run by American missionaries, where she developed a passion for literature, particularly by authors such as Georges Simenon, Victor Hugo, George Eliot, Jane Austen and Rudyard Kipling. She was a voracious reader and dreamed of becoming a writer. As Suu became older, those who had known General Aung San often said that she resembled him, particularly in her smile and the way in which she tilted her head.

The first autobiography I ever read was providentially, or prophetically, or perhaps both, *Seven Years Solitary*, by a Hungarian woman who had been in the wrong faction during the Communist Party purges of the early 1950s. At thirteen years old, I was fascinated by the determination and ingenuity with which one woman alone was able to keep her mind sharp and her spirit unbroken through the years when her only human contact was with men whose everyday preoccupation was to try to break her.

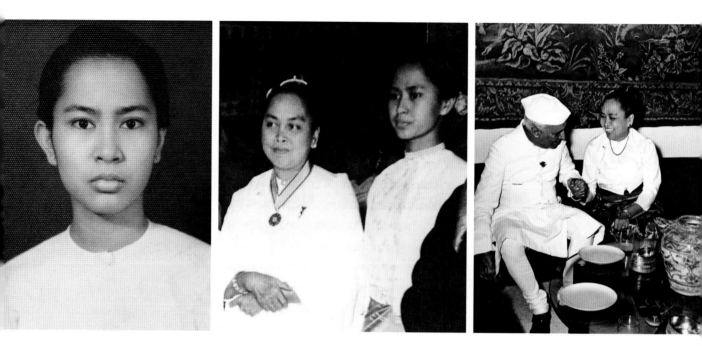

Following her mother's appointment as ambassador to India and Nepal in 1960, Suu accompanied her to New Delhi where Daw Khin Kyi continued in her efforts to turn her daughter into a refined young lady. Suu was sent to the Convent of Jesus and Mary School where she received what one of her best friends, Malavika Karlekar, described as a 'post-colonial Victorian upbringing, more than half a century after the great lady passed on'. In addition to a solid academic curriculum, she was taught sewing, embroidery, Japanese flower arrangement, horse riding and piano.

For Suu, this period in India was also an opportunity to explore and understand the country of Mahatma Gandhi and Prime Minister Jawaharlal Nehru before his death in 1964. Suu is pictured top middle with her mother, while Daw Khin Kyi is seen in conversation with Nehru top right.

1960

1940 1950 1960 1970

We were *ingénues*, sheltered from the real world . . . Sloppiness or slouching was out. For habitual loungers to whom divans with bolsters signified ultimate bliss, Suu's upright posture was a constant reminder of how young ladies should conduct themselves. Of course, the strict regimen of a convent with its insistence on well-starched divided skirts (what if ordinary skirts billowed in the wind?) just that one inch above the knees, Angelus at noon and learning by rote only reinforced familial values of discipline and order.

Malavika Karlekar, a friend of Suu's

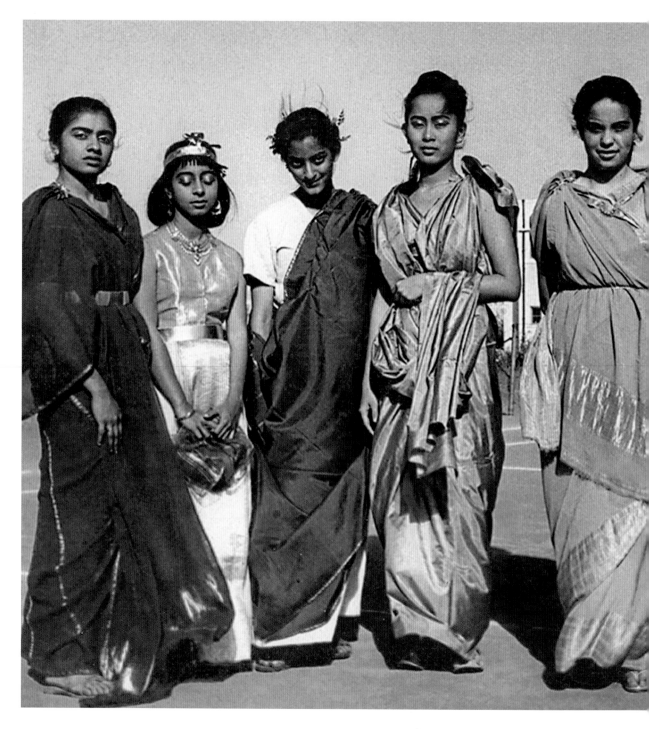

1963

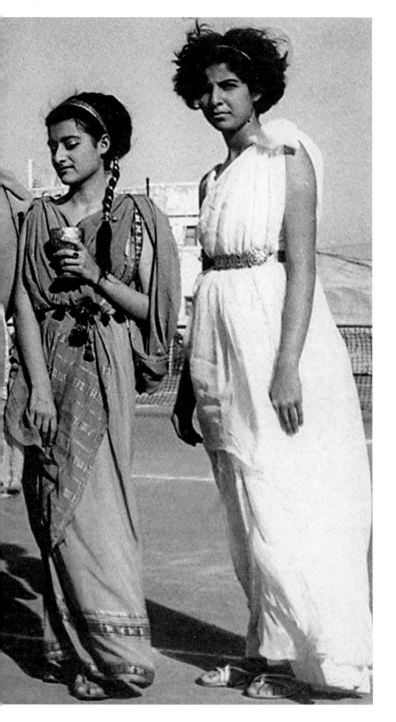

I don't think she [Suu's mother]
ever expected me to go into politics.
I think she just wanted me to be
a well-educated person who was
worthy of my father.

After finishing high school, Suu completed
a year of political science at Lady Shri Ram
College, where she also wrote and performed
in a humorous spoof of Shakespeare's
Antony and Cleopatra. In the image
featured here, Suu appears centre. Her
friend Malavika Karlekar, who also acted in
the play and appears second from the right,
wrote: 'It was very cleverly done. She had
an extremely intelligent turn of phrase . . .
She saw humour in things we found
quotidian. The quality surely emboldened
her in the dark years. She evolved into a
self-confident, attractive woman with very
definite ideas – and an irrepressible giggle.'

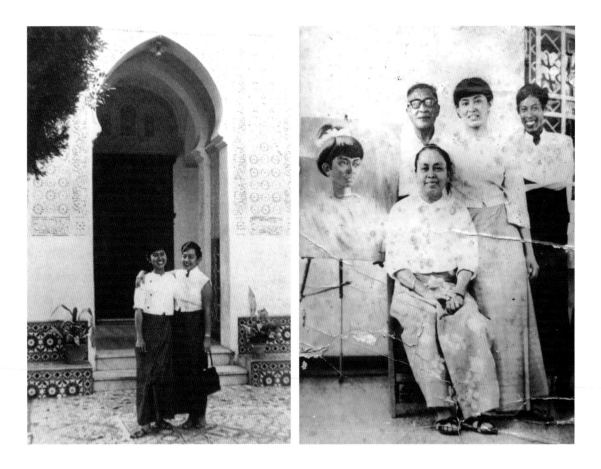

At Oxford I learned respect for the best in human civilisation . . .
It gave me a confidence in humankind and in the innate wisdom
of human beings . . . This helped me to cope with what were not
quite the best of humankind.

1964

1940 1950 1960 1970

In 1964, Suu left India to study philosophy, politics and economics at St Hugh's College at the University of Oxford, England. Although she did not sympathise with sexual liberation and the radical politics that were spreading across Europe, she blossomed during her first year of freedom in England, becoming a fashionable young woman. She cut her hair in a fringe, wore slim-fitting white jeans and rode around Oxford on a Moulton bike. During the summer of 1965, she travelled to Algeria to visit family friend Ma Than E who had been posted to Algiers by the United Nations and who appears with her arm around Suu in the left-hand image on the facing page. She spent several weeks as a volunteer in a youth camp, building houses for the widows of independence fighters. Suu also found time to return on holiday to her home in Rangoon. In the right-hand image on the facing page, she is pictured with her mother, maternal uncle and renowned modernist artist Paw Oo Thet (far right), after he completed her portrait.

During the time that Suu had been abroad, things had greatly changed in Burma. In 1962, General Ne Win had come to power with a coup d'état. He enforced the 'Burmese Way to Socialism', a series of disastrous nationalisations and autarky policies that gradually closed the country to foreigners and made it increasingly difficult for Burmese to travel abroad. The situation was worsened by the general's devotion to astrology and numerology. The black market and smuggling came to supply the needs of the people as the collectivist state slid gradually into bankruptcy. While Suu was studying in India, student protests in Rangoon resulted in universities being shut down for more than two years. General Ne Win later resolved the 'problem' of student activism by moving campuses to distant suburbs.

After Suu's graduation from Oxford in 1969, Ma Than E convinced her to enrol in a postgraduate degree at New York University. But Suu found a job at the United Nations when U Thant, the most famous Burmese statesman since the death of her father, was secretary general.

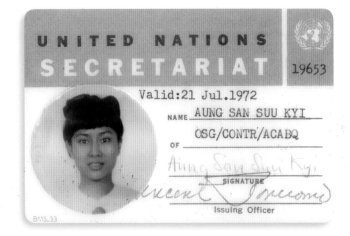

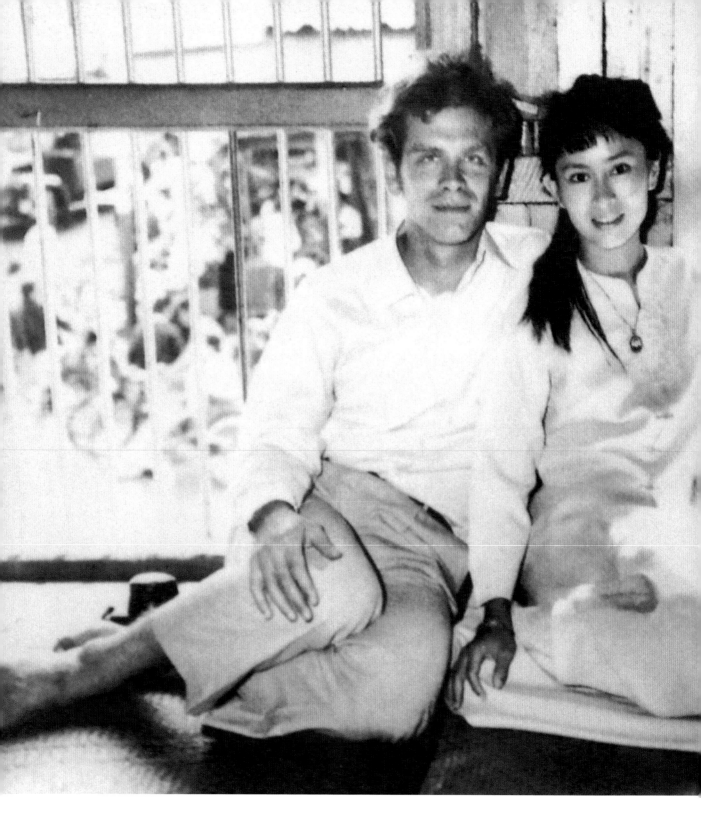

1940 1950 1960 1970

He didn't catch me
that easily. It took . . .
quite some time [laughing]!

Prior to leaving for the United States to begin her job at the
United Nations, Suu met a tall and gentle Englishman who
was specialising in Tibetan studies after finishing his degree in
modern history at Durham University. Michael Aris, pictured
here with Suu, was one year younger than her, and despite
the fact that they were both leaving England for opposite sides
of the world – she New York and he the Kingdom of Bhutan
where he was to be tutor to the regent's children – he fell in
love with her. Michael carried on his courtship by airmailed
letters, and in the summer of 1970, when he visited Suu in
New York, they became formally engaged.

I only ask one thing, that should my people need me, you would help me to do my duty by them … Sometimes I am beset by fears that circumstances and national considerations might tear us apart just when we are so happy in each other that separation would be a torment.

From a letter to Michael from Suu before their marriage

Marriage to an Englishman was a brave step for the daughter of Burma's hero who had brought about independence from England and founded the modern Burmese Army. Aung San Oo, Suu's older brother, was appalled, as were many eligible bachelors in Burma, particularly those within the military. Suu and Michael were married in a Buddhist ceremony in London on 1 January 1972 at the house of family friends Lord and Lady Gore-Booth.

1972

1940 1950 1960 1970

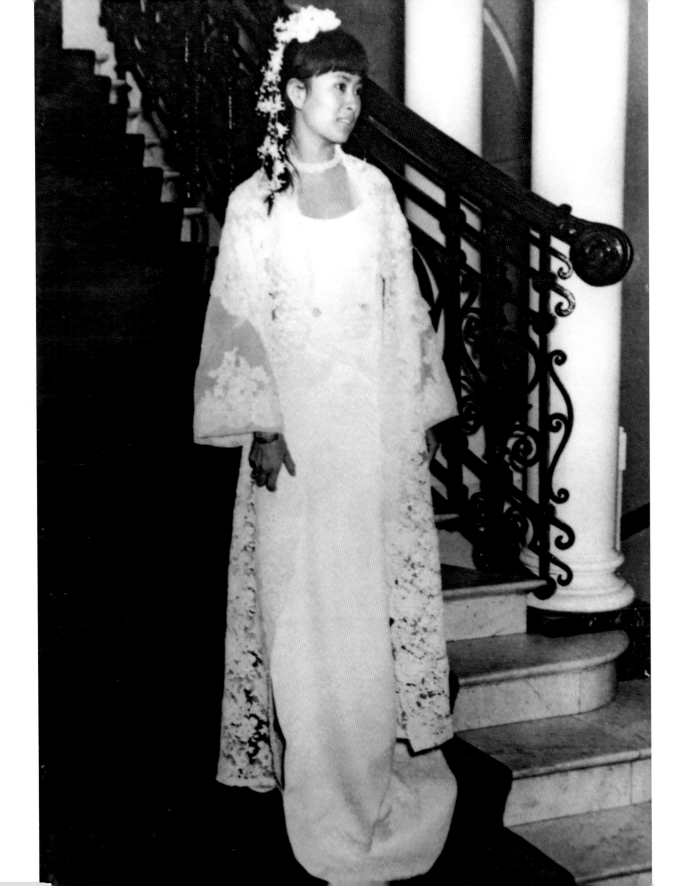

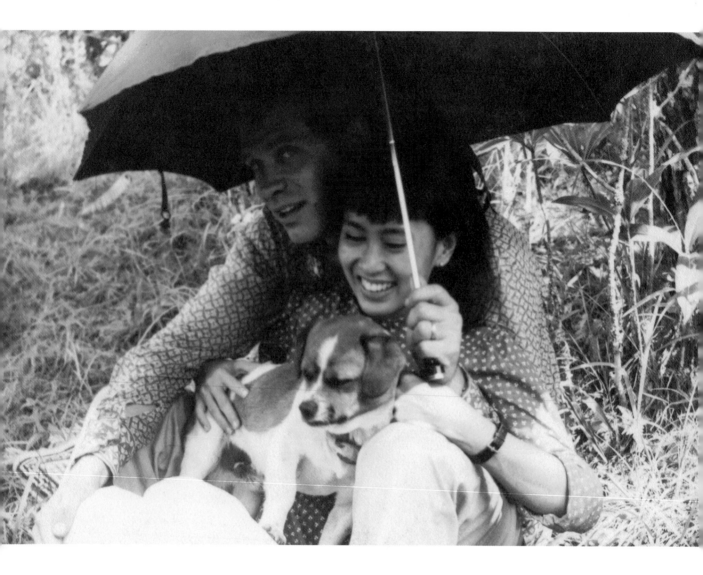

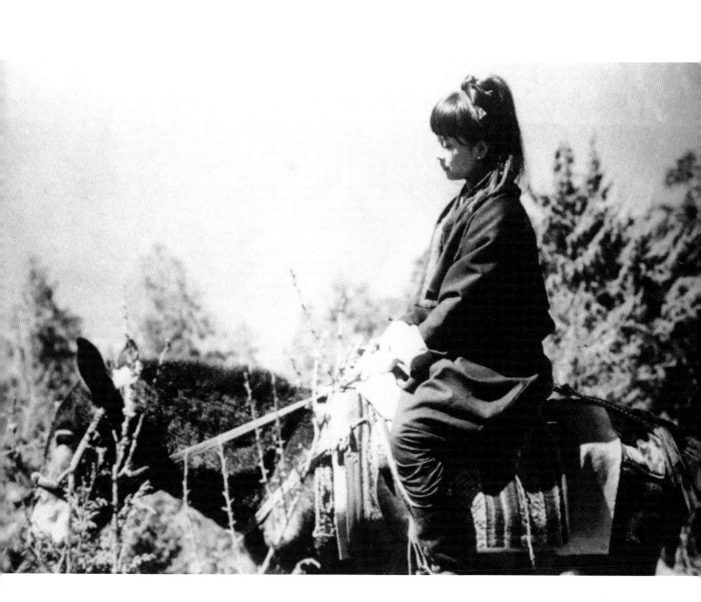

The young couple spent their first year of marriage in Thimphu, the capital of Bhutan, where Michael resumed his job as a tutor for the royal family. It was at this time that the kingdom joined the United Nations, and Suu took on a role advising the embryonic ministry of foreign affairs. During their free time, they explored the mountainous and little-known kingdom by jeep, on foot and by mule. To accompany them on their treks was a Himalayan terrier called Puppy, a gift from the king's chief minister. He became their beloved pet, and when Suu became pregnant and they decided to go back to England, he returned with them.

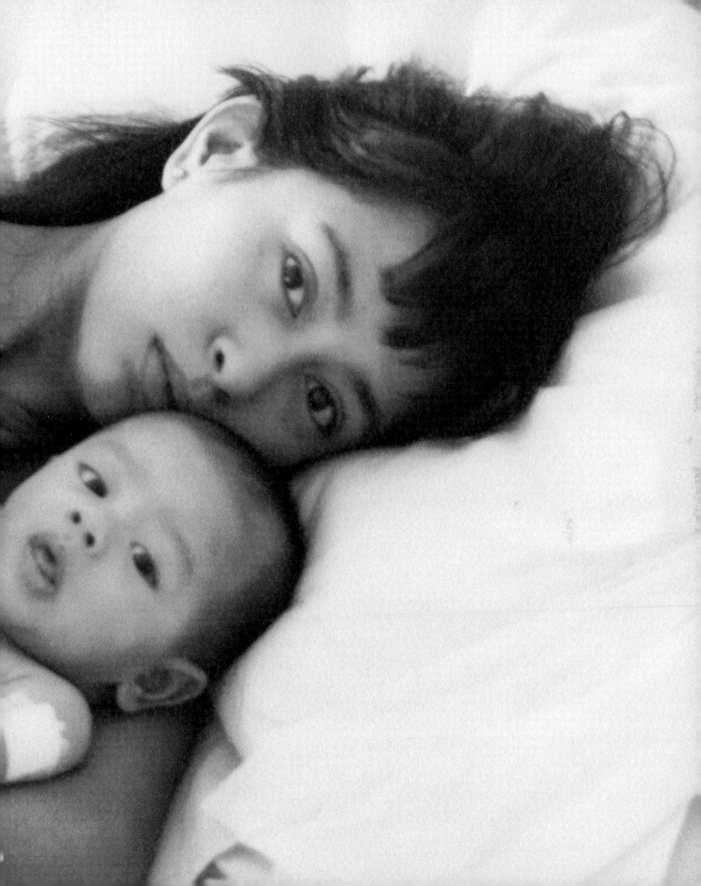

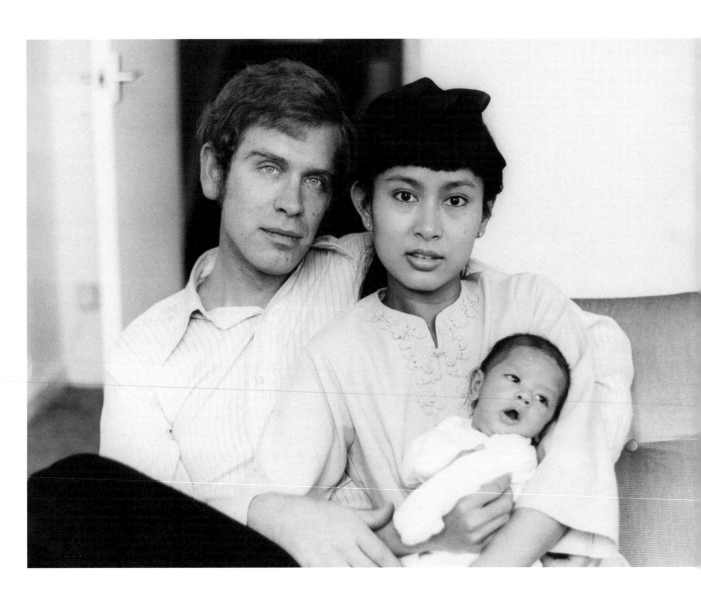

1973

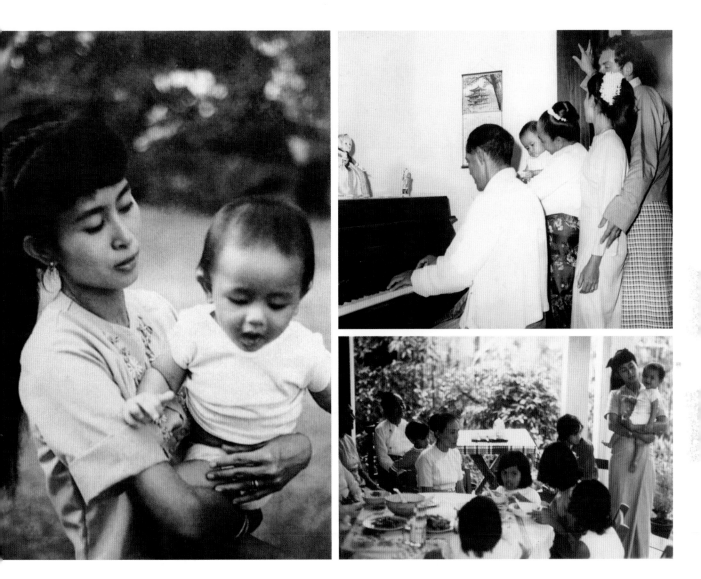

On 12 April 1973, their first child, Alexander, was born. A few months later the family headed back to Asia as Michael had been asked to lead an expedition in Nepal, close to Bhutan. While in the region, Suu and Michael also travelled to Rangoon to introduce both Michael and Alexander to Suu's mother. Despite some initial misgivings, Daw Khin Kyi gave them a warm welcome and was delighted with her son-in-law who had such polite, old-fashioned English manners.

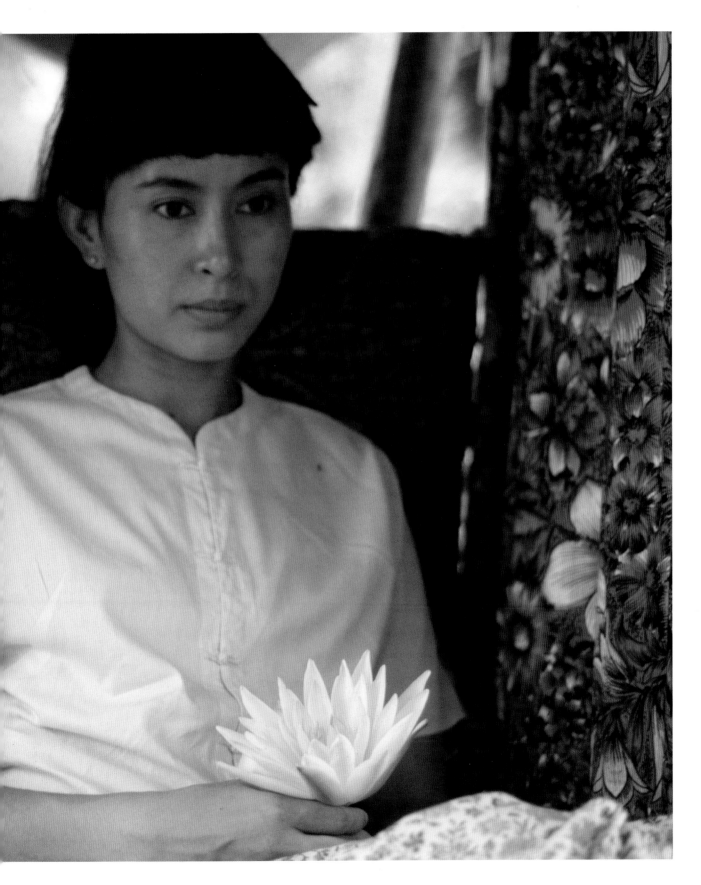

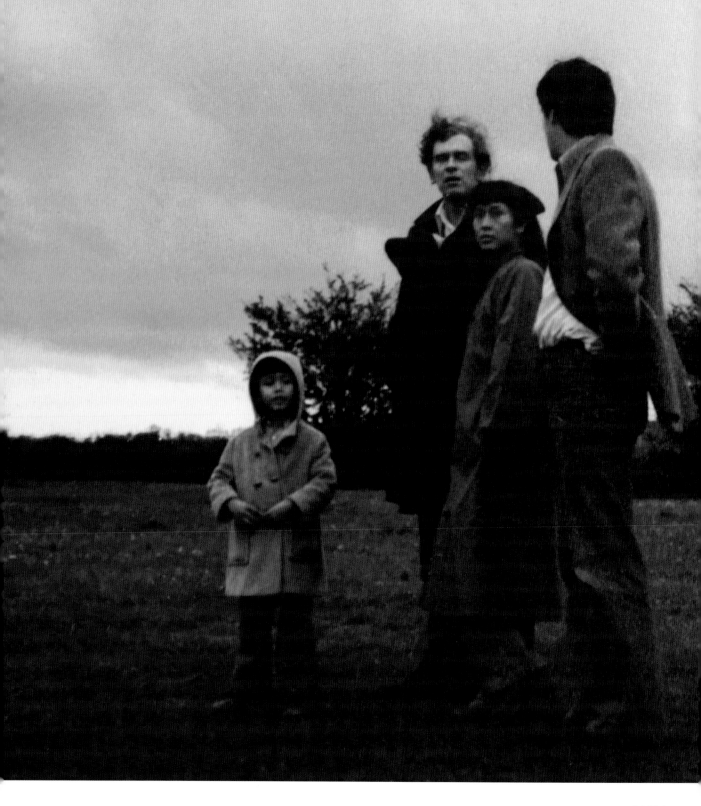

1974

She often talked about how she was perfectly content doing the ironing, her husband's socks, this sort of thing. She was bringing up two small children. She was an Oxford housewife.

Sir Robin Christopher, a friend of Michael and Suu's

It was a role she performed with pride and with a certain defiance of her more feminist friends.

Ibid

Upon their return to England in 1974, Michael's PhD proposal on the historical foundations of Bhutan was accepted by the renowned School of Oriental and African Studies at the University of London. They settled near Oxford where St John's College had awarded Michael a junior research fellowship. Although Suu had grown up in homes where servants contributed to the smooth running of the household, she took special pleasure in caring for her family and numerous guests from Burma and Bhutan who occupied the spare room of their small apartment. On 24 September 1977, Suu and Michael's second son, Kim, named after her favourite Kipling character, was born.

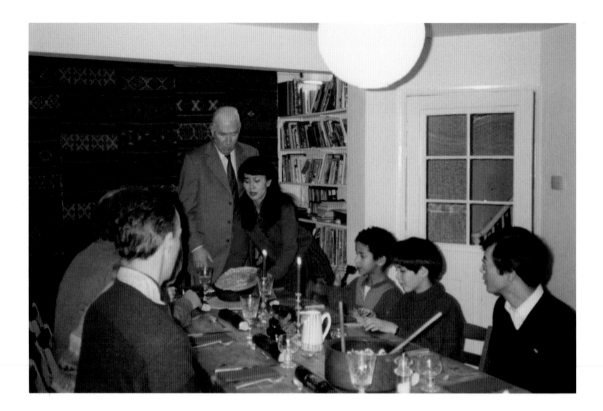

The family's situation improved when Michael's doctorate was rewarded with a full research fellowship. Both children were by then at school, and so Suu was able to have more time to herself. She began by helping Michael with his research, and soon after found a part-time job working on the Burmese collection in the Bodleian, Oxford's distinguished library. In her spare time she wrote three short books about Burma, Nepal and Bhutan, and a biography of her father. The family is pictured above, sharing Christmas dinner in 1984. Suu's father-in-law, John Aris, is standing to her right.

In 1985, Suu was in turn awarded a research fellowship by the Center for Southeast Asian Studies at Kyoto University to study Burma's independence movement. She quickly learned to read Japanese and left for Kyoto with eight-year-old Kim. The family members saw each other during the holidays, and after a year were reunited for good in Shimla, the former summer capital of India. Michael was based there, carrying out research at the Indian Institute of Advanced Study. They lived for a year in an extravagant building that had originally been built for the viceroy of India, sharing their accommodation with a number of bats and monkeys.

With my sons, I was always running around with them, playing together. Also, I would have long discussions with them – tremendously passionate arguments, because my sons can be quite argumentative, and I am argumentative too.

1984

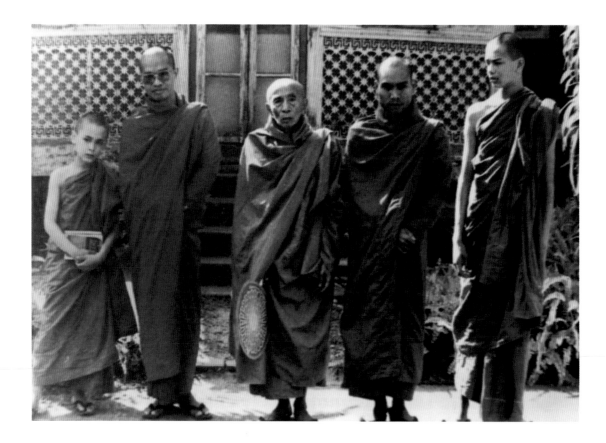

In Buddhism there are no gods to whom one can pray for favours or help. One's destiny is decided entirely by one's own actions.

It was important to Suu that her sons be raised with a full understanding and appreciation of both sides of their heritage. Alexander and Kim regularly accompanied their mother to Rangoon during the summer holidays to visit their grandmother and pay homage to their illustrious grandfather on Martyrs' Day. In 1987, Suu also made sure that Alexander and Kim underwent *shinbyu*, the Buddhist initiation ceremony. On the facing page, Alexander is on the far right and Kim is on the far left. They became novices and spent ten days at a monastery in order to deepen their understanding of the Buddhist religion and to be initiated into the practice of meditation. Suu is pictured above with her sons not long after they completed their stay with the monks.

1987

1980 1990 2000 2010

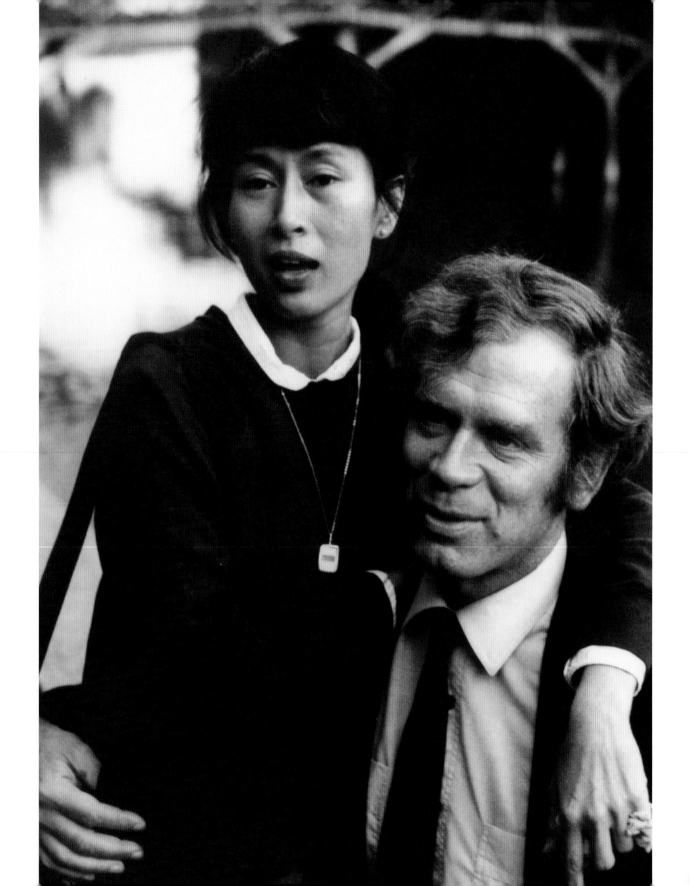

Once Suu and her family had returned to Oxford after their time in Shimla, she began work on a PhD in Burmese literature at the University of London. On the evening of Friday, 1 March 1988, however, Suu received an unexpected phone call.

My aunt rang me from Rangoon and said my mother had a stroke and that it was quite a bad one and that she thought I should come.

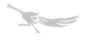

She put the phone down and at once started to pack.
I had a premonition that our lives would change forever.

Michael Aris, Suu's husband

1988

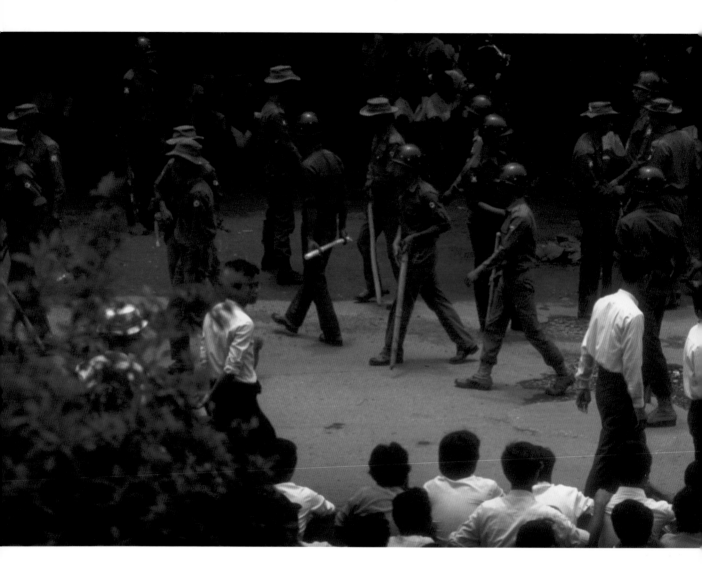

When Suu arrived in Rangoon in early April, she found her mother paralysed and in hospital, and the city on the brink of implosion. More than twenty-five years of dictatorship had transformed one of the richest nations of the region into one of the most backward. In 1987, the United Nations had just classified Burma as an LDC (Least Developed Country), which highlighted its dire economic situation. In mid-March when students took to the streets of the capital in protest, the reaction from the authorities was extremely violent. Many were shot by armed troops, while many more were forced into police trucks, with some forty being choked to death. In June, the protests resumed and so did the repression. At her mother's bedside, Suu saw the wounded stream into the hospital.

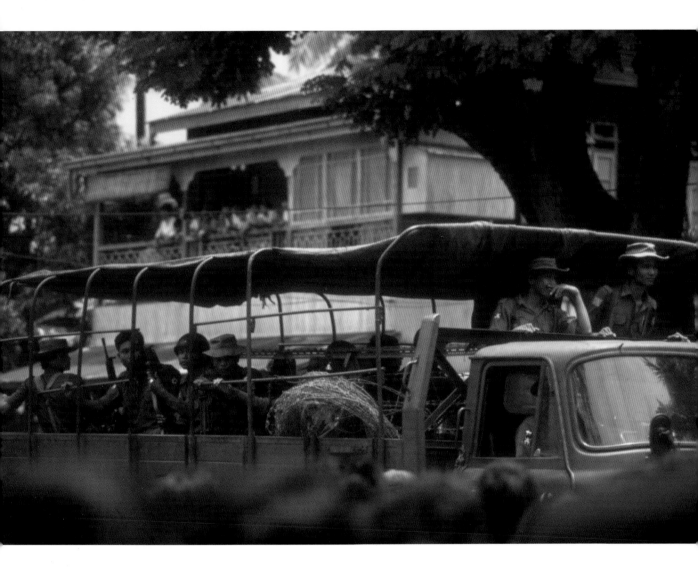

In early July, she brought her mother home to 54 University Avenue, just as Michael and the boys were flying in from London. On July 23, General Ne Win, the dictator who had been in power since the coup d'état in 1962, made a surprise announcement on television that he was stepping down. However, he made it clear that the future would still be on the army's terms: 'If there are more mob disturbances, the army will shoot to hit. There will be no firing in the air to scare.'

1988

1980 1990 2000 2010

On 8 August 1988, or 8-8-88 as the date will always be remembered in Burma, a national strike triggered a mass uprising against authoritarian rule. In Rangoon, tens of thousands of monks and civil servants joined the students to defy the martial law that had just been declared, overjoyed at the idea of an end to one-party rule. The army let the protesters march all day, but at night the tanks and soldiers went into action, shooting hundreds of people, including children.

As pictured on the facing page, bottom left, where anti-government protesters gather outside the Rangoon General Hospital on 18 August 1988, demonstrations continued even after 8-8-88. Suu did not participate in the protests, but her house had become a gathering point for dissident leaders. Soon the forty-three-year-old daughter of General Aung San was convinced she had to stand up and lead a non-violent revolt against the military regime. On 24 August, she made her first public appearance in front of the Rangoon General Hospital, as pictured on the facing page, top. She announced her intention to give a speech at a mass rally due to be held two days later at the foot of the Shwedagon Pagoda, the centre of Buddhist tradition and the symbol of national identity. Close to one million people flocked to the golden monument to listen to her. Some of the crowd is pictured on the facing page, bottom right. Protected by dozens of unarmed students who acted as bodyguards, Suu spoke without notes:

Some people have been saying . . . that I know nothing of Burmese politics. The trouble is that I know too much. My family knows best how complicated and tricky Burmese politics can be and how much my father had to suffer on this account . . . I could not as my father's daughter remain indifferent to all that was going on . . . I would like to read you something my father said about democracy: 'We must make democracy the popular creed . . . Democracy is the only ideology which is consistent with freedom . . . and strengthens peace.'

1988

1980 1990 2000 2010

After Aung San Suu Kyi's maiden speech at the Shwedagon Pagoda, a wind of liberty – some called it the Burmese spring – blew for the first time in decades. Although he belonged to the same party as Ne Win, a new civilian president lifted martial law and announced that general elections were to be held. In the following weeks the mood was euphoric. People embraced the rare opportunity to exercise freedom of speech, and newspapers flourished, with new dailies starting up and being published without censorship. Protests by all sectors of society were carried out daily against the one-party state.

She instantly became our leader and inspiration. In the evenings we would listen to the BBC and hope for guidance from our goddess. People who had been silent for twenty-six years now wanted to shout, or at least endlessly to debate.

Pascal Khoo Thwe, author

But on 18 September 1988, a new junta announced that it was assuming all power in the state. Martial law was reinstated with soldiers storming the city again. This time they were efficient and well prepared, killing thousands of students whose only weapons were Molotov cocktails and sharpened bicycle spokes fired from slingshots, known as *jinglees*. Realising that the massacre was meticulously planned, many activists fled to border areas where ethnic insurgents had been fighting the Burmese state since independence. The new set of generals in power called themselves the State Law and Order Restoration Council (SLORC). In spite of their brutal clamp-down, they proclaimed that they were not interested in long-term power and instead pledged to organise elections.

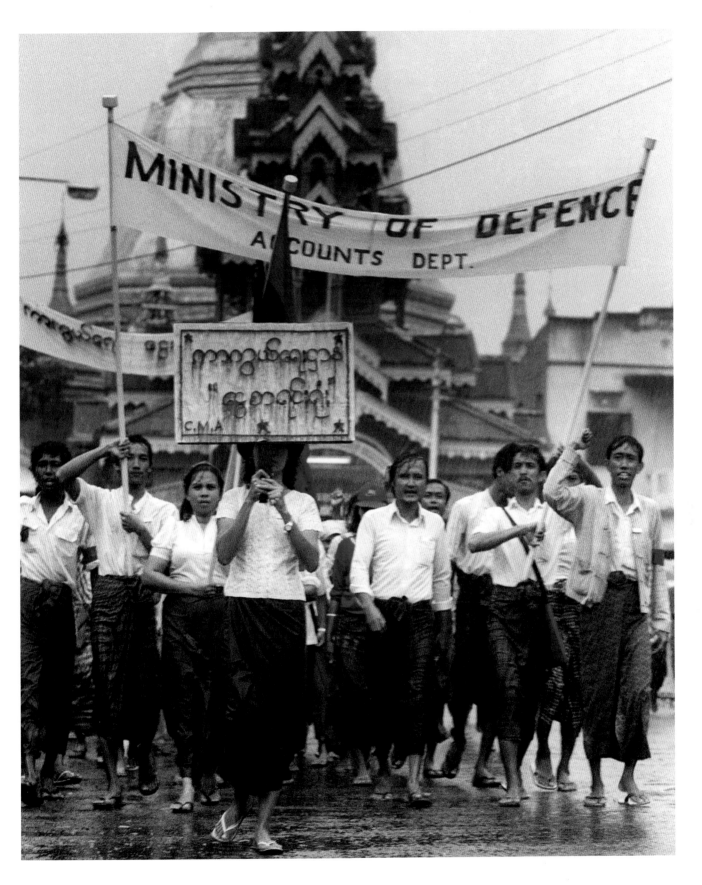

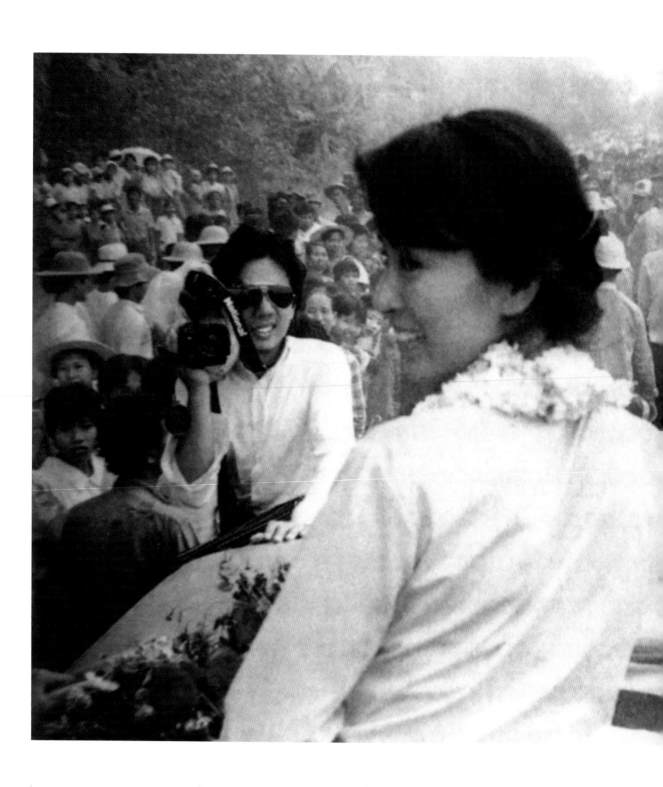

All those crowds who come to support us with such hope and trust.
I think this is going to be the biggest cross I have to bear – the feeling that I can never do enough to deserve all that trust and affection.

Suu reacted to the junta's pledge by helping to create a new political party, the National League for Democracy (NLD). Inspired by the non-violent campaigns of Martin Luther King, Jr and Mahatma Gandhi, they defied martial law by organising mass rallies and travelling around the country, where Suu was met by ecstatic crowds.

Then, on 27 December, after being semi-paralysed for months, Suu's mother passed away. Daw Khin Kyi's death was not only a moment of intense personal pain for Suu; it also represented a turning point for her as she and Michael understood that their fears of separation were being realised. She had fulfilled her duty to her mother, but her sense of duty towards her people remained. She was not going to return to Oxford, but instead would dedicate herself to Burma's democratic future.

1988

1980 1990 2000 2010

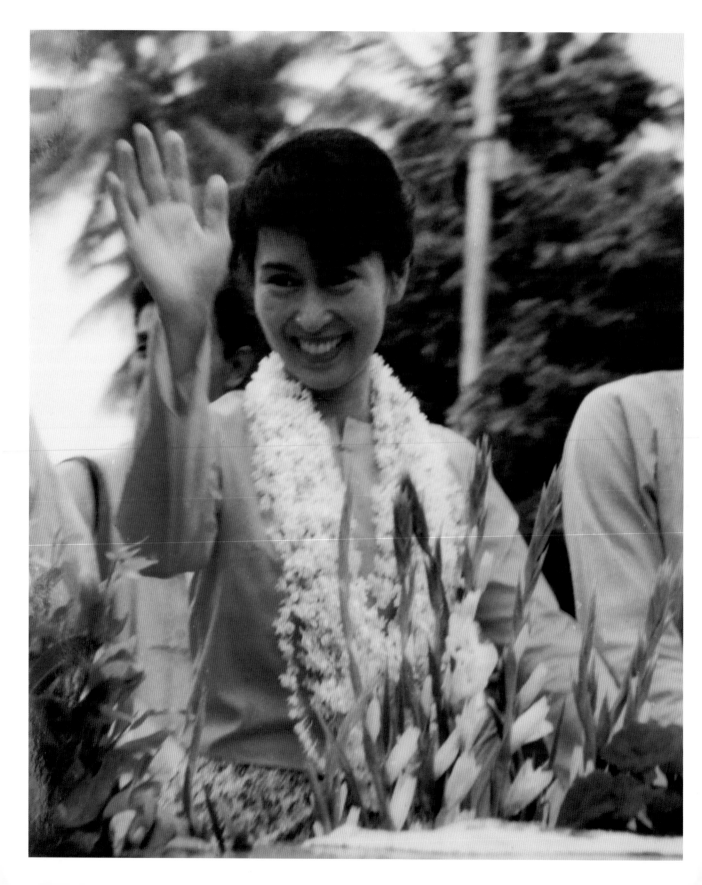

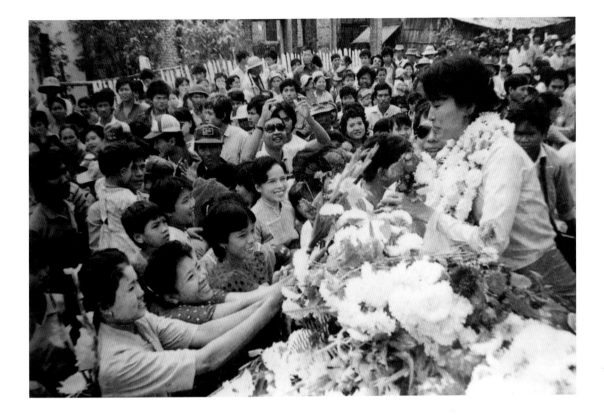

As Bertil Lintner, a journalist in Burma at the time of Suu's campaigning, later described, 'Thousands of people were waiting in the scorching sun for hours . . . Suddenly you could see a white car somewhere in the distance trailing a cloud of dust behind it . . . and the cheers were incredible. She got out, very relaxed, surrounded by her students, her bodyguards, and smiled at everybody and was garlanded, and she went up on stage and started talking. And she talked for two or three hours, and nobody left. Not even the children left . . . She was using very simple, down-to-earth words:

You've got a head, and you haven't got a head to nod with. You've been nodding for twenty-six years. The head is there for you to think . . .

And people were laughing. It was a family affair.'

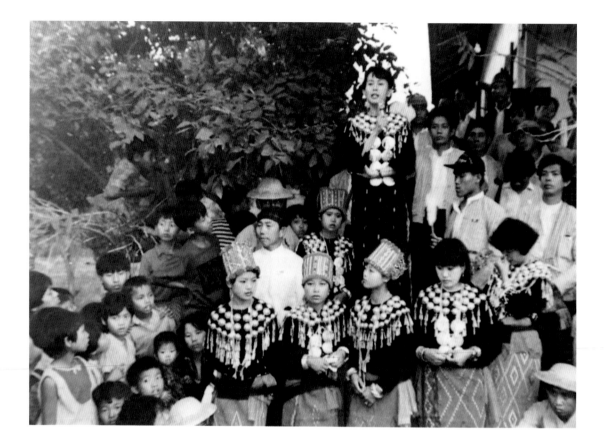

By car, by train and even by oxcart, Suu travelled across a country bigger than France. Burma is one of the world's most ethnically complex countries, containing up to forty distinct groups, each with its own language and subgroups. Apart from the Bamar majority (which makes up two-thirds of Burma's fifty-five million inhabitants), other ethnic groups include the Shan, Karen, Arakanese (Rakhine), Chinese, Indian, Mon, Chin and Kachin, whose costume and heavy silver jewellery Suu is wearing in the image above, taken in June 1989. Forty years after independence had been proclaimed, nearly twenty ethnic rebel armies were still fighting the central government for autonomy.

In May 1989, the new junta officially changed the name of the country from Burma – which they wrongly considered to be colonial – to Myanmar. Rangoon also became Yangon, and in areas with ethnic minorities, many local names were changed to sound more Burmese.

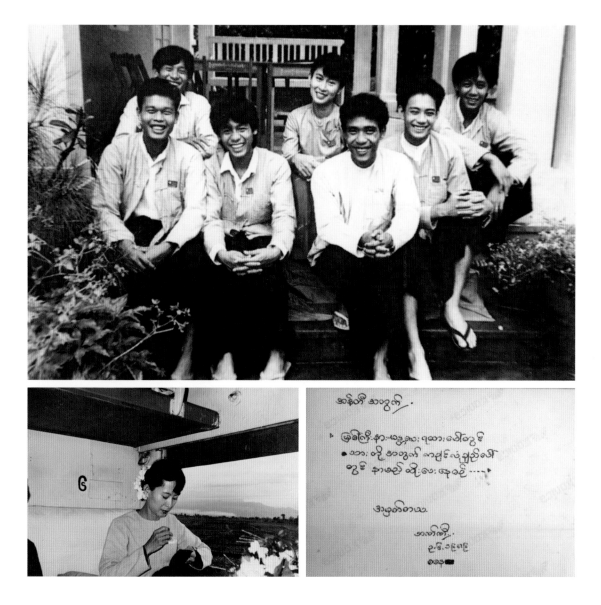

In the top image, Suu is seen at her home with 'the boys', her team of student bodyguards. The photograph bottom left was taken by Bunny, one of her protectors, who wrote the following message, bottom right, on the back: *'For Auntie. Auntie is embroidering our names on our kachin longyi* [the long cloth skirt worn by Burmese men] *while on the way to Myitkyina by train. Saturday, 3 June 1989.'*

1989

1980 1990 2000 2010

As the crowds welcoming the charismatic new leader became bigger, the NLD faced harassment by the military. Often soldiers threatened people at gunpoint to prevent them from meeting Aung San Suu Kyi. Some local leaders were arrested. Many of Suu's campaign movements took place under the watchful eye of the military, as seen in the images on the facing page.

On 5 April 1989, near the small town of Danubyu, an incident that occurred between the campaigners and the military highlighted the tension. As Suu and her colleagues were walking back to the local NLD office in the evening, an army jeep pulled up ahead of them. Six soldiers jumped out and took position, three kneeling with their guns pointed at the campaigners, three standing with their guns pointed upwards. The captain walked towards Suu's group, furious and with one arm outstretched.

He said they were going to fire if we kept on walking in the middle of the road. So I said, 'Fine, all right, we'll walk on the side of the road.' . . . He replied that he would shoot even if we walked at the side of the road. Now that seemed highly unreasonable to me [laughing]. I thought, if he's going to shoot us even if we walk at the side of the road, well, perhaps it is me they want to shoot. I thought, I might as well walk in the middle of the road . . . One doesn't turn back in a situation like this.

Just as the tension was becoming unbearable, with the soldiers readying themselves to fire, a major appeared and ran towards the soldiers, shouting and ordering them not to shoot. Suu brushed past them as the captain tore off his epaulettes in a rage, shouting, 'What are these for?'

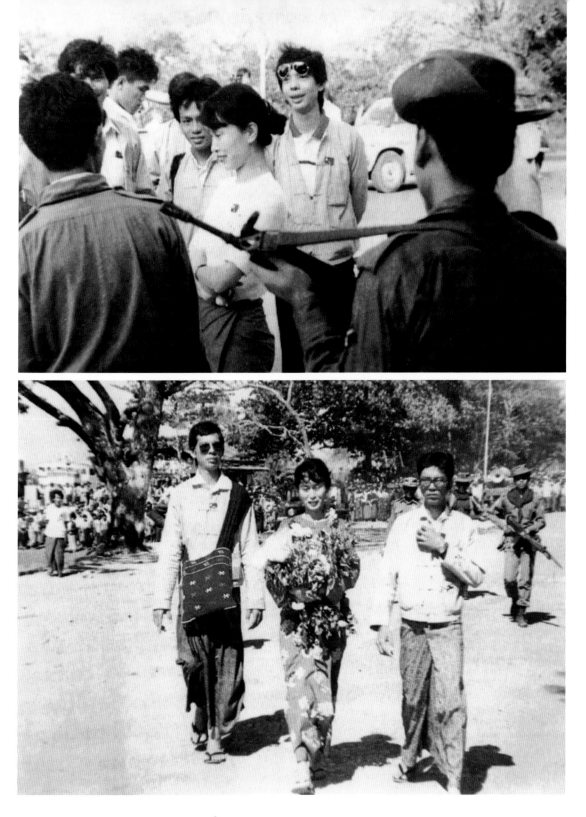

1989

1980 1990 2000 2010

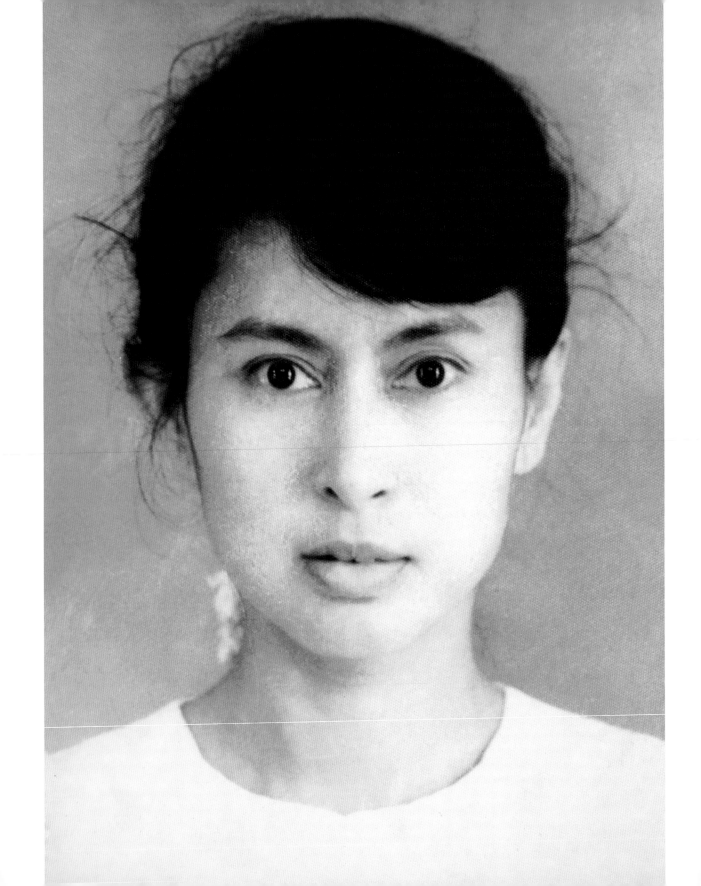

The rift between the government and the democracy movement continued to deepen. It reached a point of no return when the NLD initiated a campaign of non-violent civil disobedience, exhorting the people to 'defy every order and authority not agreed by the majority'. Then, for the first time, Suu attacked the dictator by name in a press conference:

General Ne Win is still widely believed to control Burma behind the scenes . . . The opinion of all our people is that he is still creating all the problems in this country. He caused the nation to suffer for twenty-six years and lowered the prestige of the armed forces.

On 20 July 1989, the military reacted by putting thousands of NLD leaders and members in jail, while its secretary general, Aung San Suu Kyi, and chairman, U Tin Oo, were placed under house arrest for 'endangering the state'. Complacent, the SLORC thought that the opposition had been rendered powerless, and confident that they would win, permitted the elections to go ahead as planned on 27 May 1990. To the ruling party's immense surprise, however, the NLD gained 80 per cent of the seats. But with no intention of handing over power, and fearful of the public's reaction to the news, the military took six weeks to announce the results, claiming that the elections had not been for a new parliament but instead for a constitutional convention. Sixty-two newly elected members of the NLD were sent to jail, and Suu remained under house arrest. She knew that she was in a much easier position than her fellow NLD members because she had the protection of her father's name – the founder of the Burmese army. She demanded to join them in prison, and when her request was refused she went on a hunger strike for twelve days. Finally, she accepted a compromise: the military's solemn word that her colleagues would not be tortured, and that the cases against them would be heard by due process of law. As another sign of solidarity with those who were imprisoned in harsh conditions, including being prevented from seeing their families and sometimes even being locked in a dog cage for months at a time, Suu rejected food provided by the regime. She asked her guards to sell her furniture to buy staple goods. She also refused to receive letters and parcels.

The first years were the worst . . . they threw me in at the deep end.

Sometimes I didn't even have enough money to eat. I became so weak from malnourishment that my hair fell out, and I couldn't get out of bed. I was afraid that I had damaged my heart. Every time I moved, my heart went thump-thump-thump, and it was hard to breathe. I fell to nearly 90 pounds from my normal 106 . . . Then my eyes started to go bad. I developed spondylosis, which is a degeneration of the spinal column . . . [Pointing with a finger to her head] But they never got me up here.

I think in the end it depends on each of us to find if we are a prisoner within our own mind or not. I never considered myself a prisoner. I always followed a path of my choice.

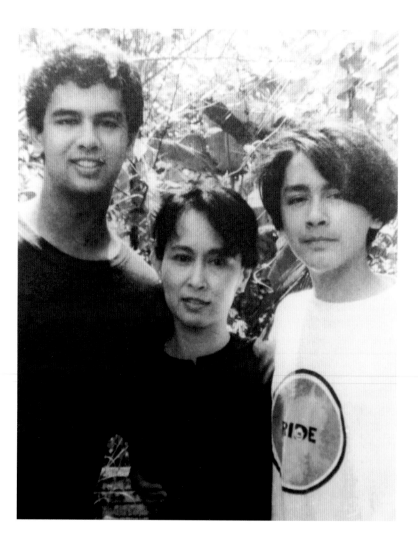

The first Christmas following Suu's house arrest, Michael was allowed to visit, but the junta did not let Alexander and Kim accompany their father. Suu was only reunited with her sons in 1993, as pictured above. In the meantime, Michael's work to keep the world's attention on his wife's struggle was recompensed in December 1991, when Aung San Suu Kyi was awarded the Nobel Peace Prize. Alexander and Kim received the award on behalf of their mother who instructed them to use the US$1.3 million prize money to establish a health and education trust for young, exiled Burmese. It would be twenty-one years later, in June 2012, that Aung San Suu Kyi was able to travel to Oslo to accept her prize and deliver her acceptance speech.

She is an outstanding example of the power of the powerless.

Václav Havel, former president of the Czech Republic

Although my mother is often described as a political dissident who strives by peaceful means for democratic change, we should remember that her quest is basically spiritual. As she has said, 'The quintessential revolution is that of the spirit', and she has written of the 'essential spiritual aims' of the struggle. The realisation depends solely on human responsibility.

Alexander Aris, Suu's son

1993

Of course I regret not having been able to spend time with my family. One wants to be together with one's family. That's what families are about. Of course I have regrets about that – personal regrets. I would like to have been together with my family. I would like to have seen my sons growing up. But I don't have doubts about the fact that I had to choose to stay with my people here.

As it became clear that the generals welcomed Suu's departure from Burma, she faced an excruciating choice – to remain confined in Yangon in support of her people or to rejoin her husband and sons in England. She knew that if she chose to leave, she would not be allowed to return. She chose to stay.

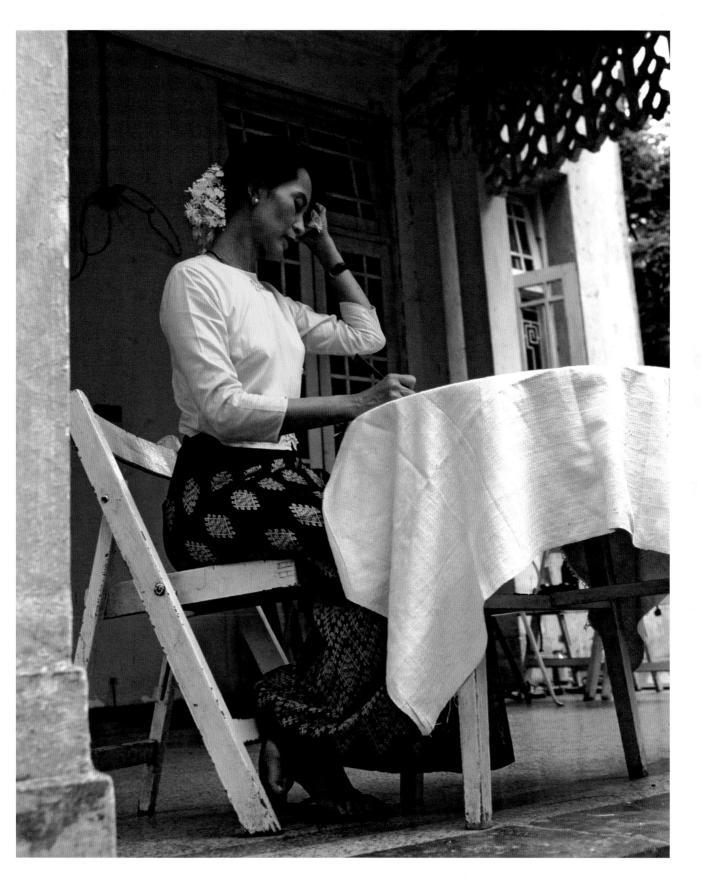

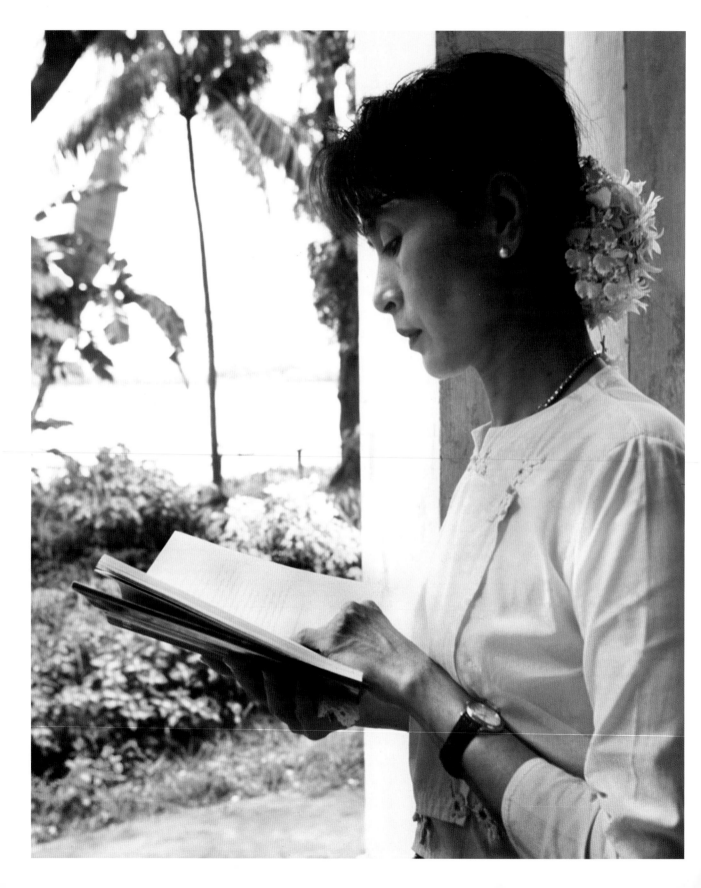

During her confinement, Suu developed a strict daily routine. She would rise at half past four every morning and turn the light off at nine o'clock at night. To start the day, she would meditate for an hour to develop a sense of calm and awareness. After some exercise, she would then have breakfast, listen to the BBC's Burmese-language programme, read and write, play the piano or learn French from tapes. In addition, there was always something to repair in the old family house, especially during the monsoon season, when 'every spare basin, bucket, saucepan and plastic container in my house has to be commandeered to catch the rivulets that flow in merrily.'

I decided to put my time under detention to good use by practising meditation. It was not an easy process. I did not have a teacher and my early attempts were more than a little frustrating.

I've always said that one of my greatest weaknesses is having a short temper. I tend to get angry quite quickly. This is a lack of ability to raise yourself above the immediate situation. This is where I have found that meditation helps – it gives you a sense of awareness that helps you to observe and control your feelings.

With what should I compare this world?
With the white wake left behind
A ship that dawn watched row away
Out of its own conceiving mind.

Standing on the verandah in the stillness of a monsoon afternoon, Suu savours some of her favourite lines translated from the *Manyoshu*, the oldest existing collection of Japanese poetry.

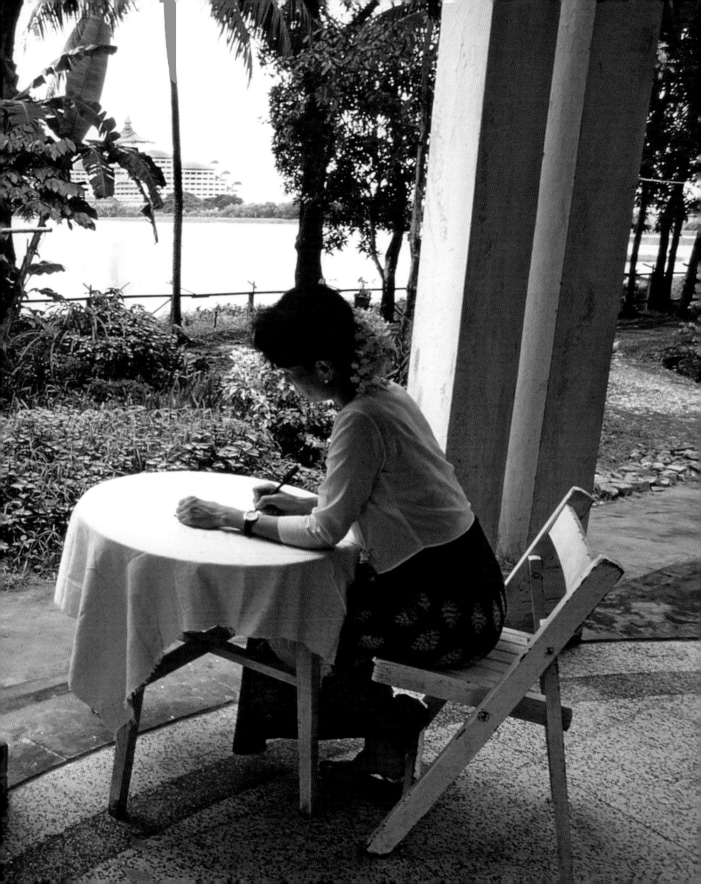

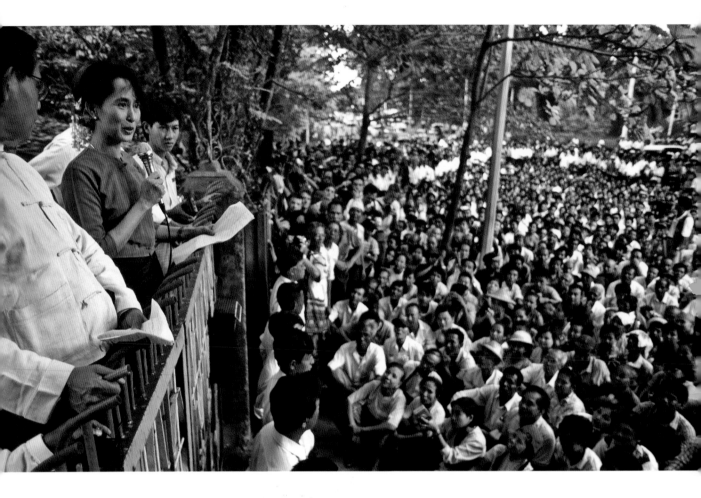

On 10 June 1995, after six years of house arrest, Suu was released with no explanation. Her detention was to become characterised by the arbitrary way in which the junta released and then rearrested her a number of times. The government had just announced the launch of 'Visit Myanmar Year' and was expecting to lure tourists and foreign investors – especially Japanese. The gate to Suu's house became a daily meeting place for her supporters. Suu would speak to them standing on a table next to the gate, holding on to the spikes.

Today she is no longer exactly a prisoner in her house. After six years of house arrest,

she was released from the prison that was her home into the prison that is her country.

Michael Aris, Suu's husband

1940 1950 1960 1970

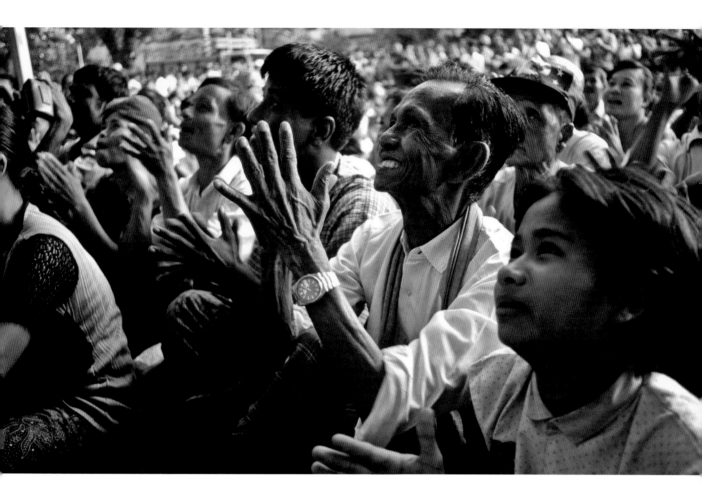

On my release, people gathered outside the gate to demonstrate their support. It was
the monsoon season and they would wait in the rain until I went out to speak to them . . .
This continued day after day for more than a month. Then I negotiated with our supporters
an arrangement which was more convenient: we would meet regularly on Saturdays and
Sundays. I also invited them to write to me about matters they would like me to discuss
and leave their letters in the mailbox.

1995

1980 1990 2000 2010

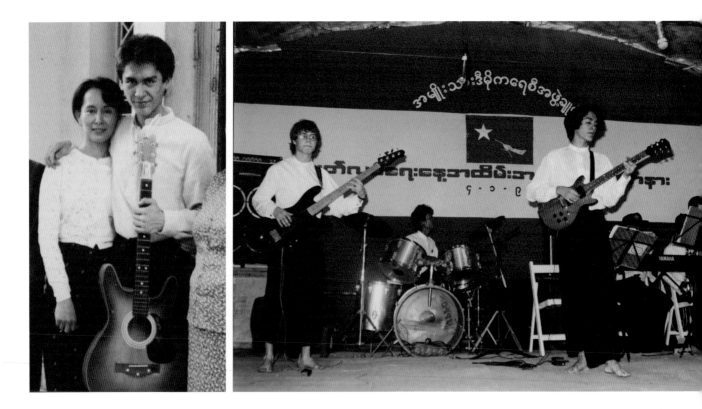

Following Suu's release in 1995, her family was allowed to visit. Kim was by that time developing his skills as a musician, and the following year would play in a rock band during the Independence Day celebrations in Yangon.

[Kim] brought his music with him . . . and he would say, 'Now, do you know who that is, Mummy?' Well, first, of course, I'd get it all wrong, but later I began to learn who was who. He played a lot of Bob Marley, so I learned to like Bob Marley: 'Stand up, stand up for your rights.' Perfect for us!

Yes, I never stop him [from playing his music loudly in the house] because I don't like him listening to his music on the earphones. I think that damages his ears. I'd rather put up with all that noise than have him damage his ears.

1995

1980 1990 2000 2010

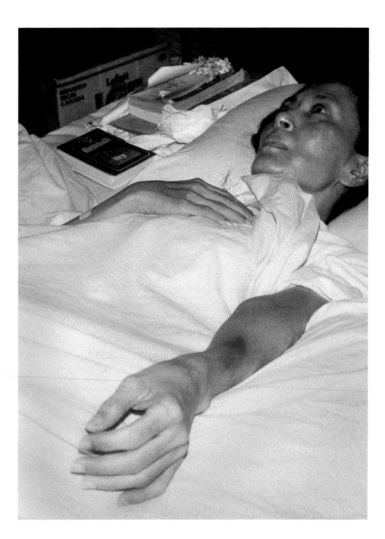

Suu had been released, but the junta made no signs of initiating talks with the head of the opposition. As the crowds attending her weekend talks grew larger, the military reacted by barricading the road and threatening those who continued to attend with long prison sentences. In a further show of power, the military prevented her from leaving the city, clearly marking the geographical limits of her new 'freedom'. Every time Suu tried to drive out of Yangon she was stopped by the police. On one occasion in August 1998, she remained in Dala, on the southern outskirts of the city, for nine days, refusing to return home. Eventually, she was dragged out of her car by a two-hundred-strong detachment of riot police, and was returned home malnourished and bruised.

If the army really wants to kill me, they can do it without
any problems at all, so there is no point in making elaborate
security arrangements. It is no bravado or anything like that.
I suppose I am just rather down to earth and I just don't see
the point to this worry.

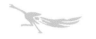

Saints, it has been said, are the sinners who go on trying.
So free men are the oppressed who go on trying and who in
the process make themselves fit to bear the responsibilities
and to uphold the disciplines which will maintain a free society.

1998

1980 1990 2000 2010

In 1999, Michael was diagnosed with terminal cancer. With his typical dry humour, he announced to Peter Carey, one of his best friends, 'Well, I've got two pieces of news for you, Peter: one good, one bad. The bad thing is that I've got cancer; the good thing is that I'm going to beat it.'

The military regime used this opportunity to increase the pressure on Suu. Despite appeals from Prince Charles and Countess Mountbatten, the generals refused to grant Michael a visa to visit Burma. They then added to Suu's torment by casting her in the media as a heartless wife who refused to take her rightful place at her husband's sickbed. Michael and Suu were only able to speak on the phone. They agreed that leaving would be equal to abandoning her people, as she would not be permitted to return.

Food and freedom were the issues: food for the families of those that were imprisoned, who would have completely gone under without her help, while she felt her closest followers would almost certainly have been arrested once she was out of the way.

Sir Robin Christopher, a friend of Michael and Suu's

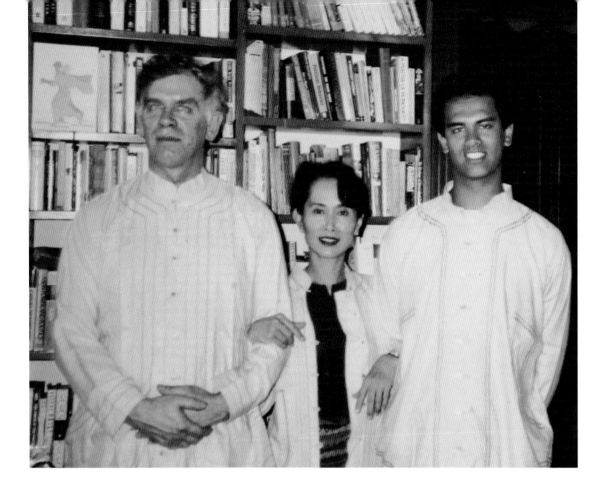

Michael died on 27 March 1999, his fifty-third birthday and just under three months after Suu had learned of his illness.

She did cry when she received the news that her husband had passed away, but there was only a short moment when she got emotional. Then she got over it and was the one consoling the people who visited her.

Su Su Lwin, a friend of Suu's

I think she's genuinely strong, and even if she's sad, she knows she's got to get on with things – she's not going to waste time crying about it.

Kim Aris, Suu's son

1999

1980 1990 2000 2010

Placed under house arrest again in September 2000, Suu was released in May 2002 and even allowed to travel outside Rangoon. During that time the rising star in the junta was General Khin Nyunt. He had managed to sign ceasefire agreements with most of the ethnic rebel armies and had also negotiated gas deals with foreign petrol companies. As Suu remained the prime obstacle to the regime's acceptance by the international community and to economic sanctions being lifted, Khin Nyunt initiated secret negotiations with her. But Senior General Than Shwe, or 'Number One', pictured in the right-hand image on the facing page, had another plan for the Nobel laureate and her ever-growing popularity.

On 30 May 2003, Suu's campaign team and her supporters were attacked near the town of Depayin by thousands of members of the USDA (Union Solidarity and Development Association), a mass organisation created by the head of the junta. Using baseball bats and bamboo rods, they struck hundreds of people down, including women. As one of Suu's bodyguards reported later: 'When victims, covered in blood, fell to the ground, the attackers grabbed their hair and pounded their heads on the pavement . . . screaming the words, "Die! Die! Die!"'

Seventy people died in the massacre. Suu's driver was able to save her by forcing the car through barbed wire after the attackers began to break its windows.

It is not power that corrupts but fear. Fear of losing power corrupts those who wield it and fear of the scourge of power corrupts those who are subject to it.

2002

1980 1990 2000 2010

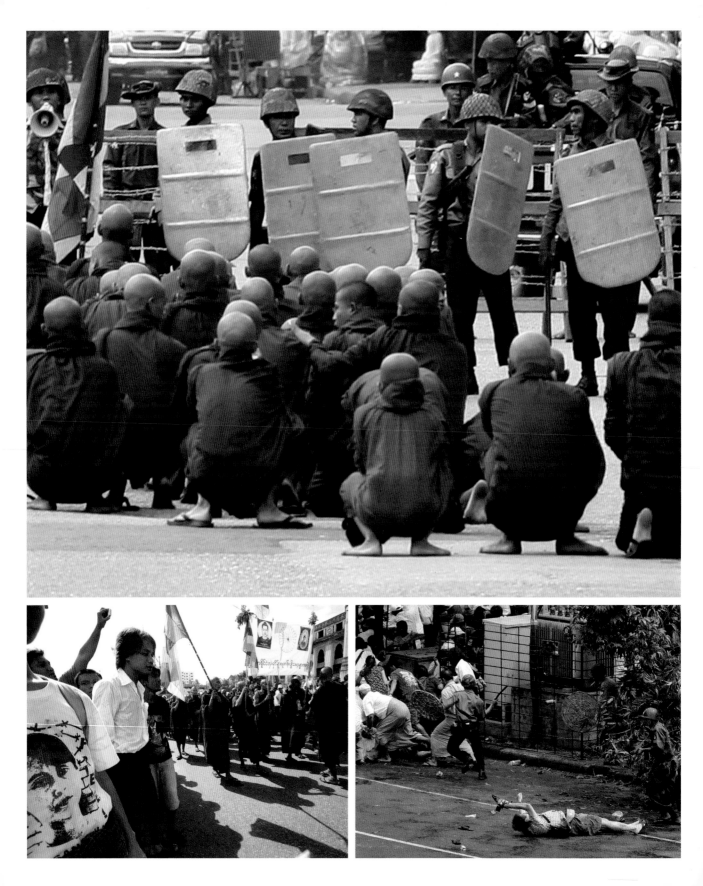

Within a system which denies the existence of basic human rights, fear tends to be the order of the day. Fear of imprisonment, fear of torture, fear of death, fear of losing friends, family, property or means of livelihood . . . Yet even under the most crushing state machinery, courage rises up again and again, for fear is not the natural state of civilized man.

Following the massacre, not one of the assailants had been investigated, but a number of NLD leaders were arrested, and Suu had vanished. It later transpired that she had been held in secret detention in Insein prison for more three months. She was then taken back to her residence to be once again placed under house arrest. Four years later on 22 September 2007, she made a brief public appearance at her gate to accept the blessings of thousands of Buddhist monks who were marching in support of human rights and against the poor management of the economy by the junta. Protest marches continued, as seen on the facing page where monks pass in front of the Yangon City Hall on 25 September 2007. What was to become known internationally as the 'Saffron Revolution' had begun the previous month, and continued each day until a crackdown by the military left more than one hundred people dead, including Japanese photojournalist Kenji Nagai, pictured on the facing page, bottom right. Many more protesters were detained, and under the Television and Video Act, which prohibited people from owning televisions and video equipment without a licence, many received long-term prison sentences of up to sixty-five years.

2007

1980 1990 2000 2010

I am very happy to see you. It has been a long time! . . . The military gave me seven years of rest. Now I am full of energy to continue my work.

On 13 November 2010, Aung San Suu Kyi was released again. She had been imprisoned for fifteen of the last twenty years, but emerged at sixty-five as radiant as the flowers she likes to adorn her hair with. *The Times* reported that 'some people sobbed out loud, many shed tears and everybody shouted words of salutation and love. For ten minutes Aung San Suu Kyi could do nothing but bathe in the acclaim of the crowd.'

On the surface, Yangon appeared to have changed a great deal. Male students were abandoning the traditional *longyi* for jeans, and were spending time on Facebook in Internet cafes. But Myanmar, as it was now officially called, was still the poorest country of the region, and some 1,200 political prisoners remained incarcerated.

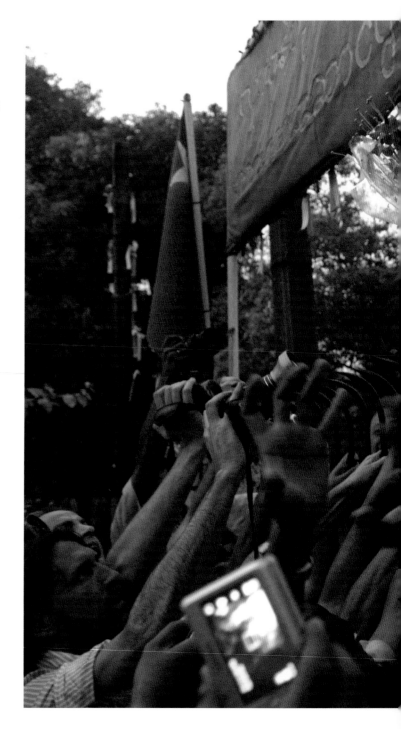

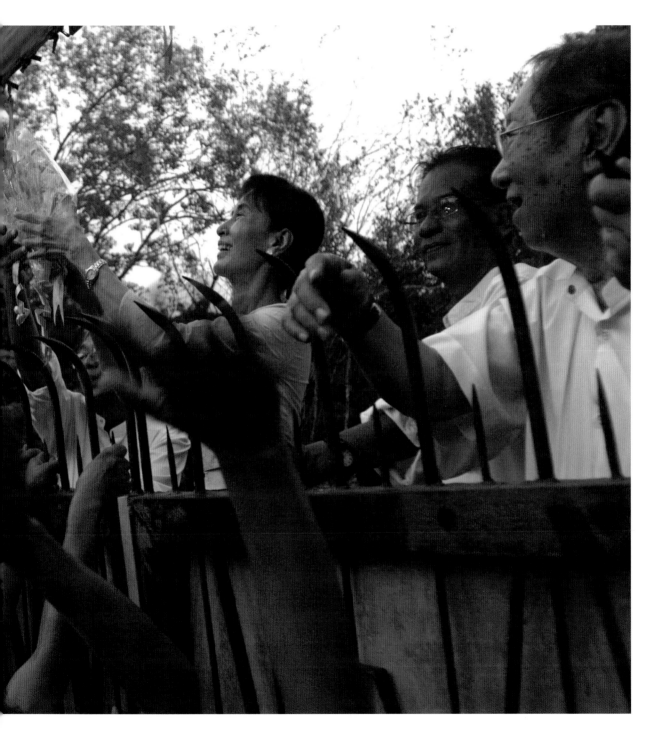

1980 1990 2000 2010

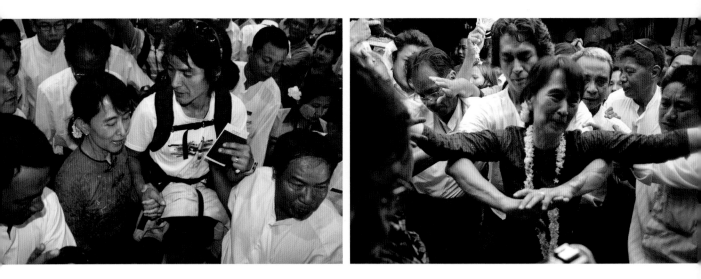

Shortly after Suu's release, Kim was granted a visa to see his mother – it was for the first time in ten years. He visited her again in July 2011 to take part in celebrations for her sixty-sixth birthday and to accompany her on a trip to Bagan, her first expedition outside Yangon since 2003. As always, the crowd was delighted to see her, causing Kim to hold her close, protecting her from excited well-wishers who wanted to touch her. On the facing page, Suu and Kim can be seen visiting the Shwedagon Pagoda in Yangon with other NLD members.

My sons are very good to me.
They've been very kind and understanding.

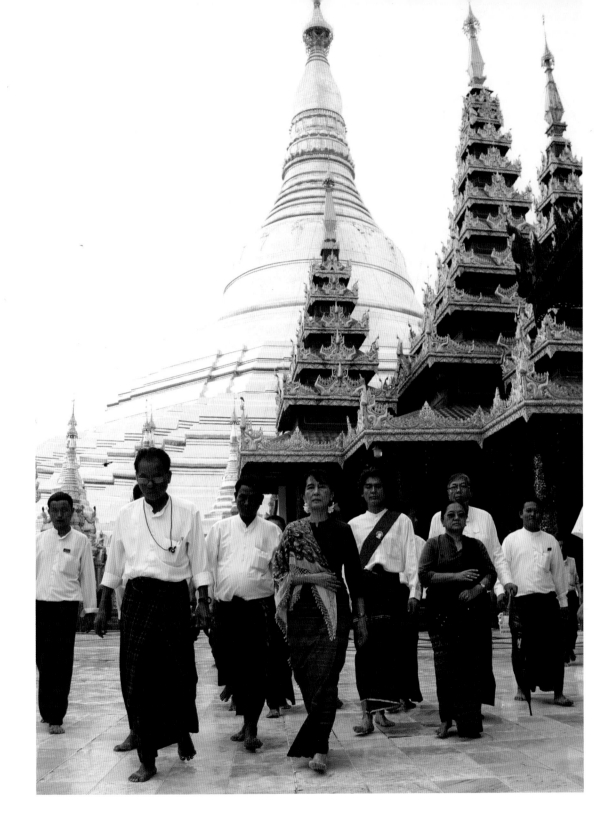

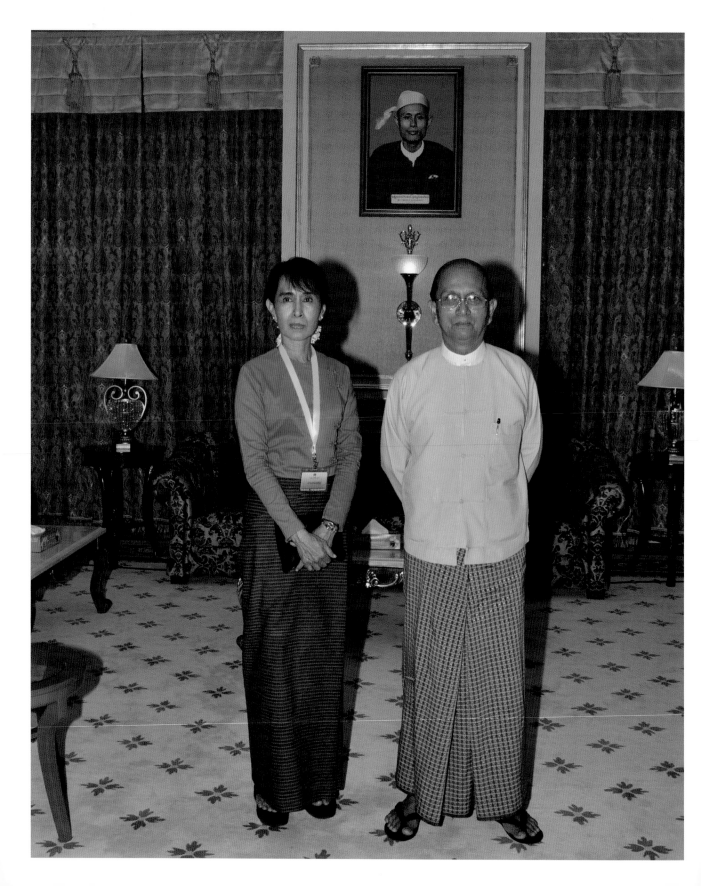

In the first few months after Aung San Suu Kyi's release in November 2010, it looked as if the political situation was still in deadlock. But the generals were beginning to consider change inevitable. The country was being swallowed economically by China. A rapprochement with the United States was the only way in which Burma could counter-balance the relationship with its powerful neighbour and bring about an easing of western sanctions. Before officially retiring, the junta organised parliamentary elections. These were boycotted by the NLD, mainly because under the new constitution, 25 per cent of the seats were automatically reserved for the military. Nevertheless, when the new civilian president, U Thein Sein, a former general and prime minister of the junta, invited Suu to the new capital of Naypyidaw, he and his wife welcomed her especially warmly. After their meeting on 19 August 2011, the president and Aung San Suu Kyi posed symbolically for the media under a portrait of her father.

It went well. I thought he was somebody who could be trusted and that he was genuine about wishing to bring reform to the country. We've said very, very openly that the military needs to be behind the reform process if it is to be irreversible.

President U Thein Sein proposed that Suu and the NLD rejoin the political process by participating in by-elections: forty-eight parliamentary seats had been left vacant since cabinet members had assumed their posts. On 18 January 2012, Suu formally registered to contest a lower-house seat in the Kawmhu township constituency, south of Yangon. The special by-elections were to be held on 1 April 2012.

2011

People give me flowers
all the time and I wear
as many of them as I can.
My mother often quoted
a Burmese saying: 'A man
without knowledge is like
a flower without a scent.'
I prefer scented flowers.

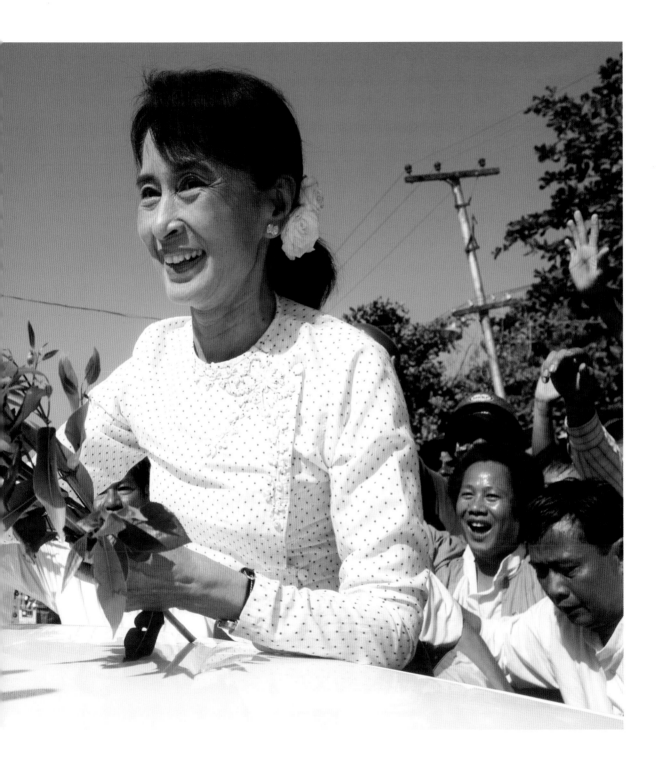

I think she's taken a gamble … She had to do that if she wanted to test the sincerity and to support the reform efforts. She knows what the alternative is; the alternative is more of the same: a new generation of military leaders takes over from the outgoing generation and there is no … real path that is going to lead to a better future.

Hillary Clinton, former US secretary of state

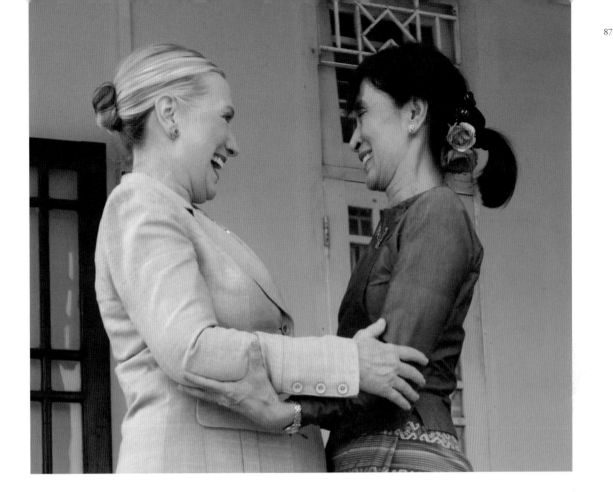

After being a prisoner for so many years, Aung San Suu Kyi's decision to engage with her former captors brought US Secretary of State Hillary Clinton to Burma in December 2011.

I felt a real sense of elation about the moment. It was like talking to a girlfriend . . . For three hours we just talked. I also deeply admired and empathised with the personal cost of what she has done. She doesn't like to talk about that. She doesn't like to have people feel sorry for her because she made decisions.

Hillary Clinton, former US secretary of state

2012

1980 1990 2000 2010

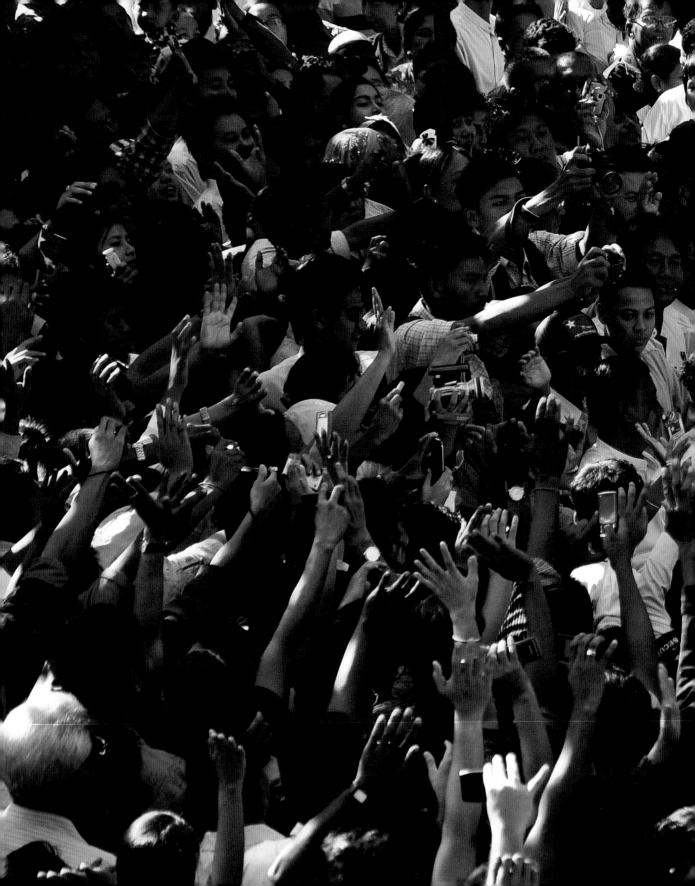

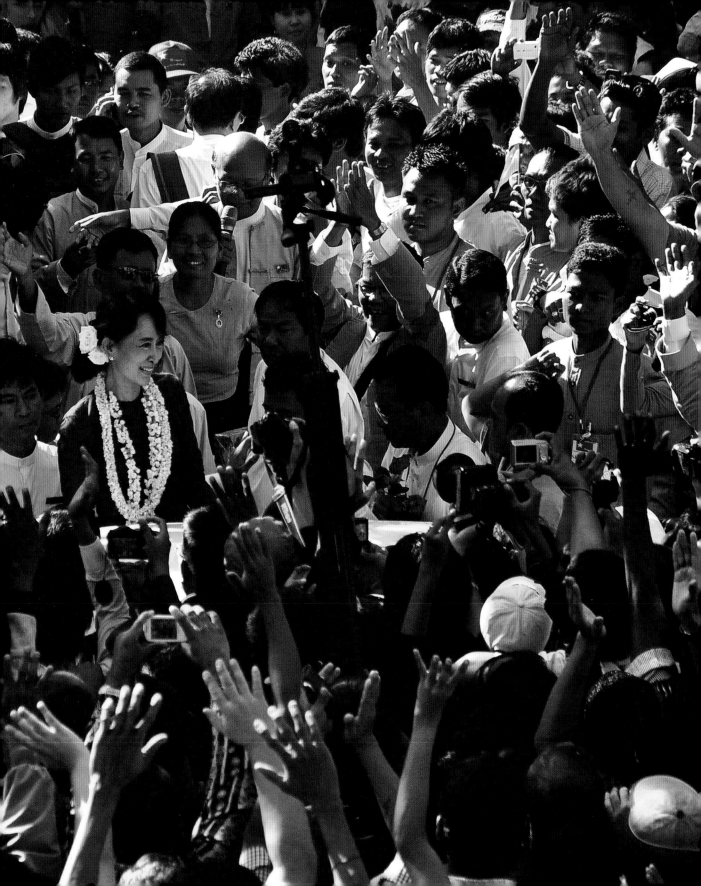

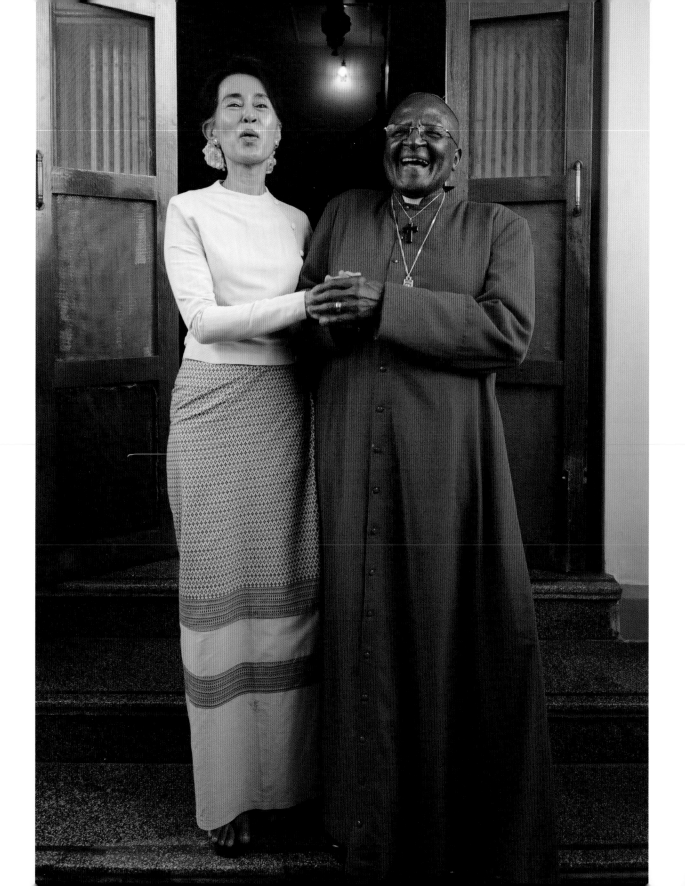

I've always felt that if I had really started hating my captors, hating the SLORC and the army, I would have defeated myself.

This remarkable woman said that she bore no one malice; she nursed no grudges against those who had treated her so unjustly; she had no bitterness; and she was ready to work for the healing of her motherland, which had suffered so grievously. In revealing this extraordinary magnanimity she was emulating Nelson Mandela . . . Without forgiveness there can be no future. Forgiveness is not a nebulous spiritual thing. It is practical politics.

Archbishop Desmond Tutu

Soon after the historic meeting between President U Thein Sein and Aung San Suu Kyi, the new parliament voted a surprising series of laws beginning with the legalisation of trade unions and the right to demonstrate. Then, in a rare concession to public pressure, the government ordered the suspension of a controversial two-billion-dollar hydroelectric project led by a state-owned Chinese company. Finally, most of the political prisoners were released, among them the student leaders of 1988, Min Ko Naing and Ko Jimmy.

Why did Nelson Mandela trust de Klerk? Why did he decide he was going to engage in a discussion about a political transition with . . . the leader of the apartheid regime? It's a feel. There's no scientific formula for it, but for authentic leaders such as she is, you have to listen to yourself and you have to say, 'Is this a risk worth taking?' And she decided it was, and I'm going to give her every bit of support I can.

Hillary Clinton, former US secretary of state

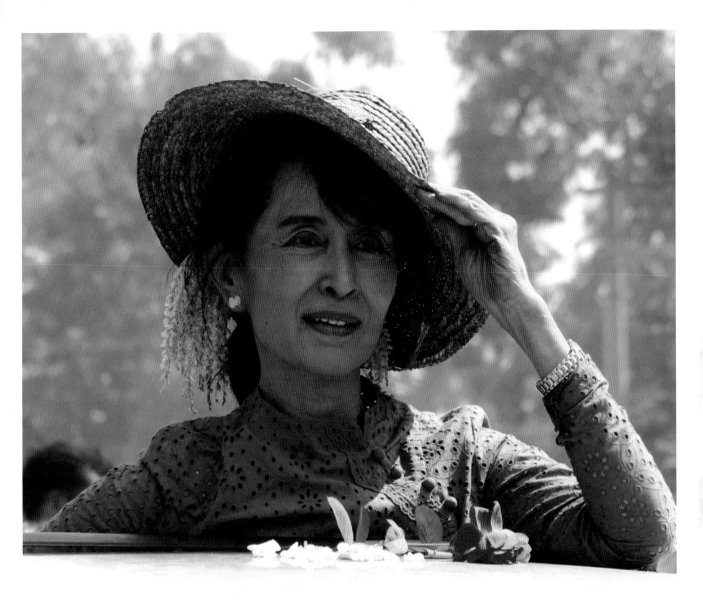

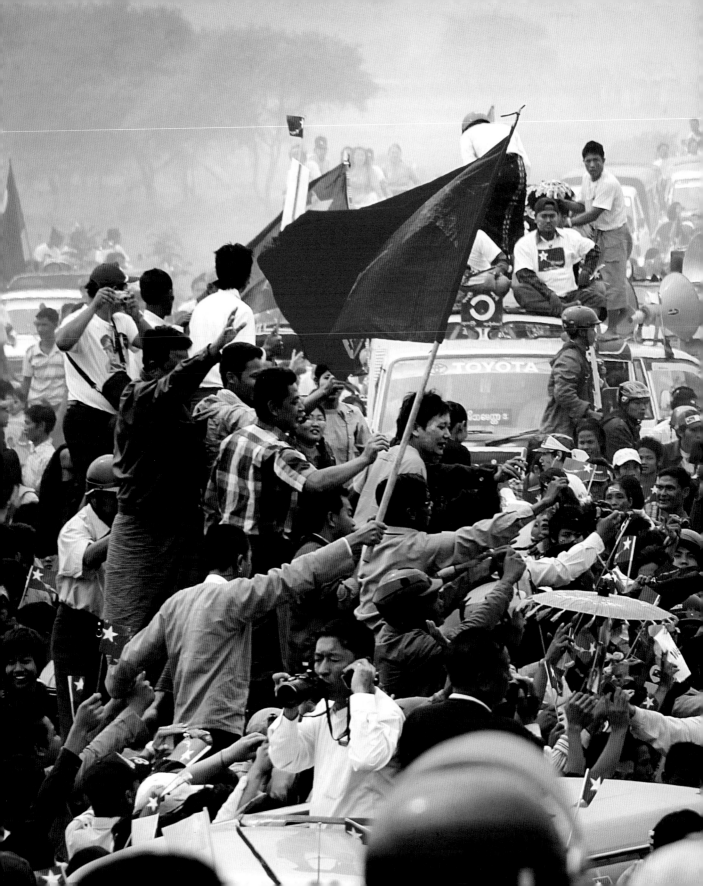

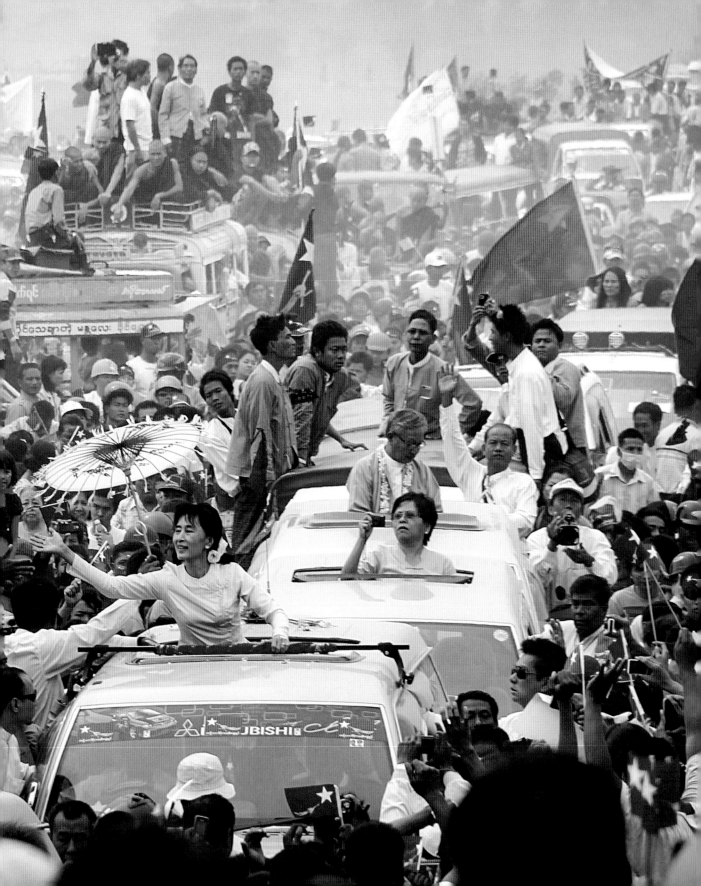

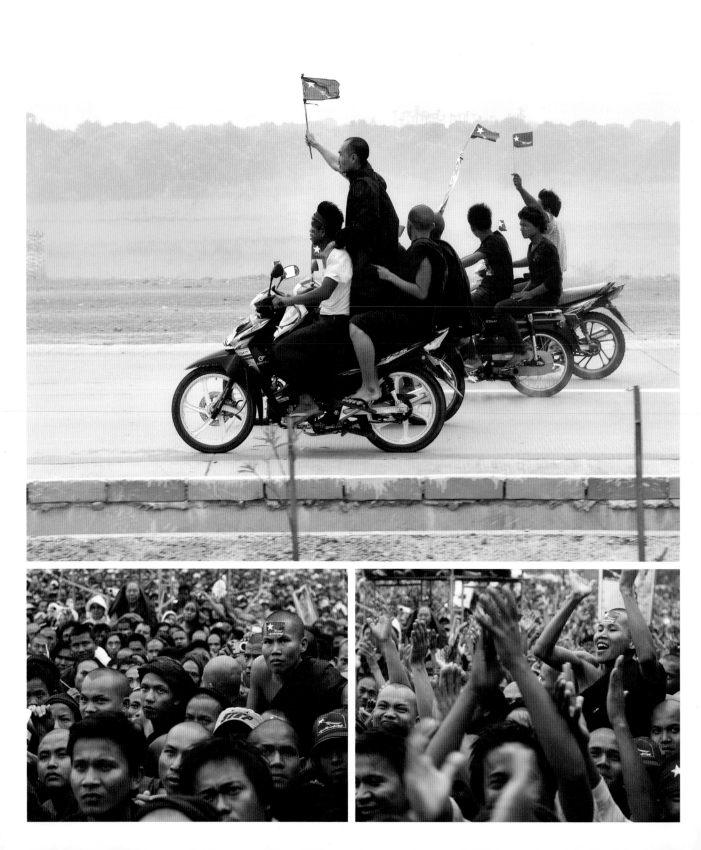

There are only forty-eight seats to be won in these by-elections. Even if we win them all, we will have only forty-eight members of parliament [out of 664] but it is worth fighting for!

Twenty-two years after the NLD's massive election victory in 1990, Aung San Suu Kyi was back on the campaign trail across the country. A whole new generation openly expressed its love for the one they now called *Amay* (Mother). The sacrifice that she had not deviated from over so many years had created an inalterable bond with her people.

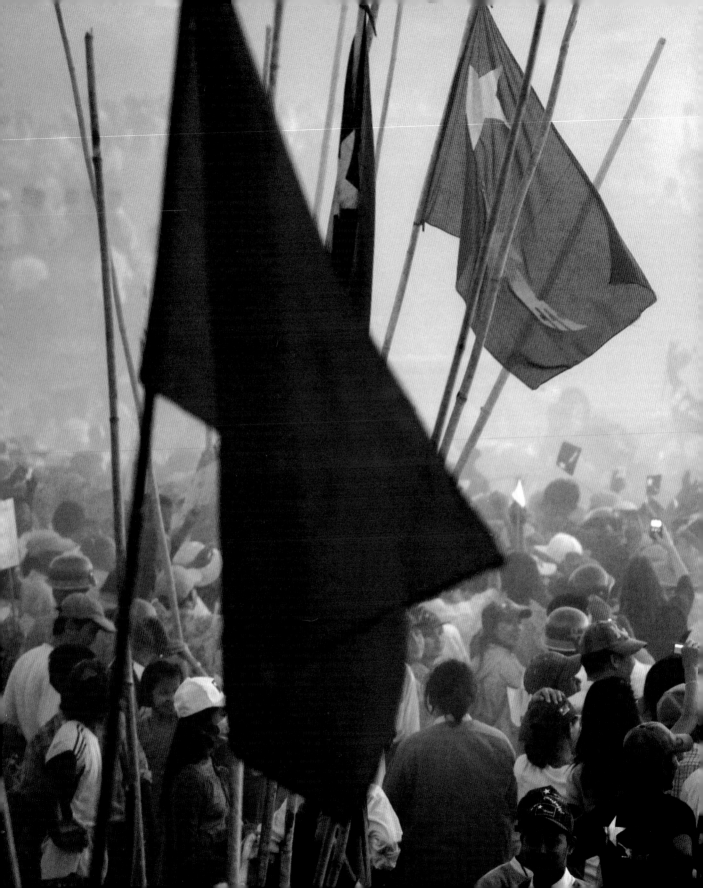

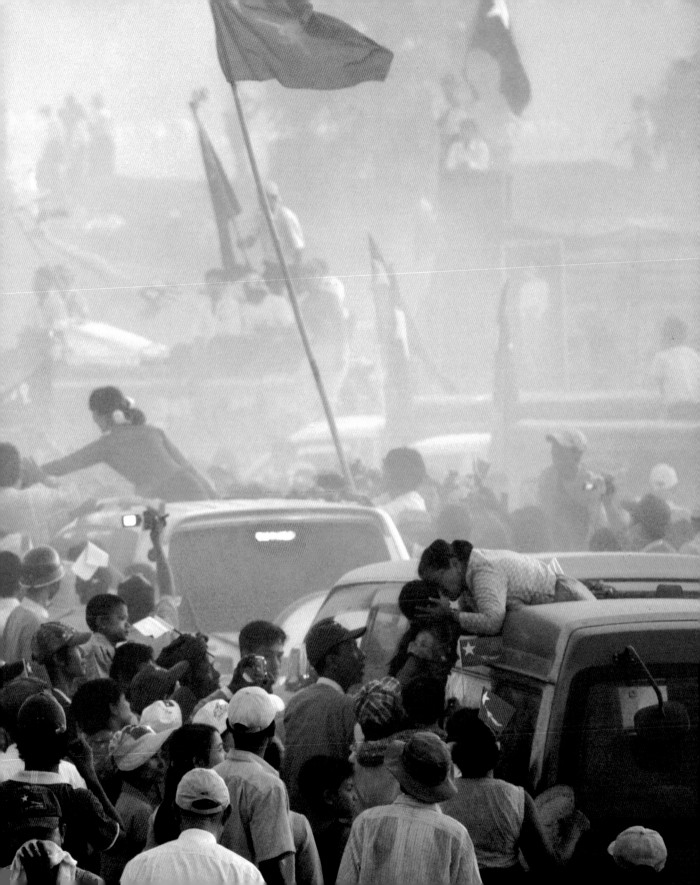

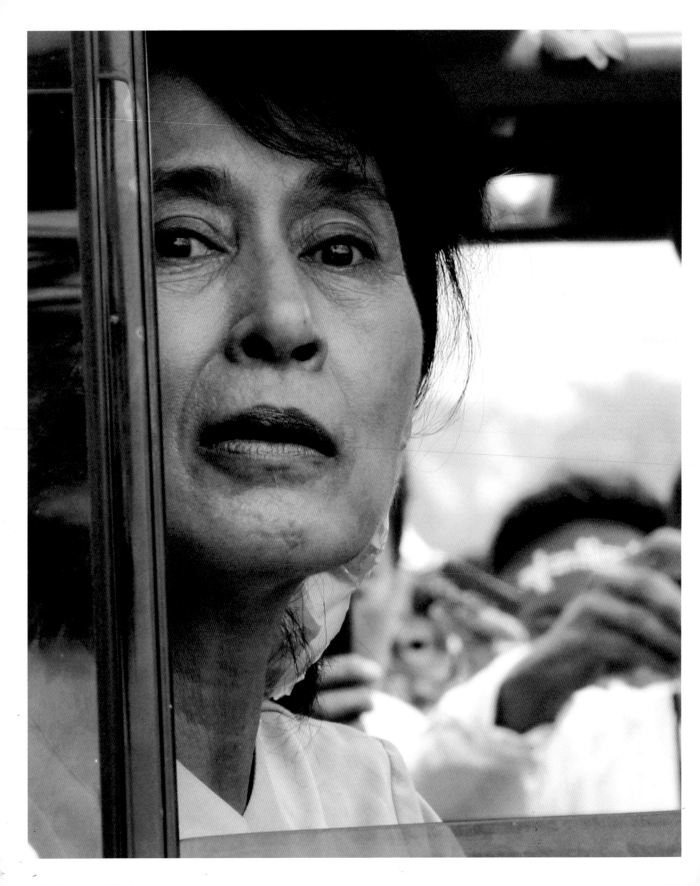

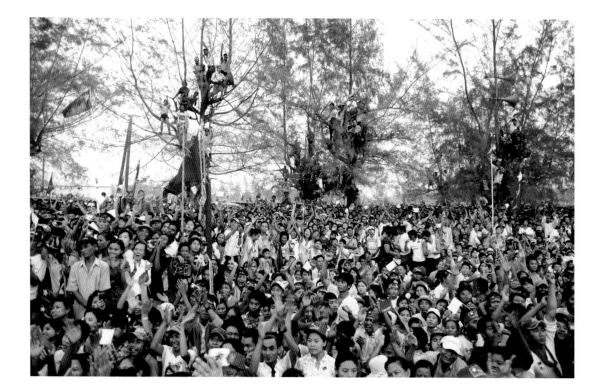

In spite of Burma's vast natural resources, after half a century of mismanagement and pervasive government controls, the task of rebuilding the country is immense. Burma is the poorest country in Southeast Asia with a GDP per capita of only US$1,400. One-third of the population lives below the poverty line, and it is not rare to meet young children working hard for less than US$1.50 a day. The new government has embarked on a notable programme of economic reforms to attract foreign investment but, as emphasised in a CIA report, corruption is prevalent and most resources are concentrated in only a few hands.

These elections are a big step forward but don't think that the difficulties are behind. The hardest part still needs to be done.

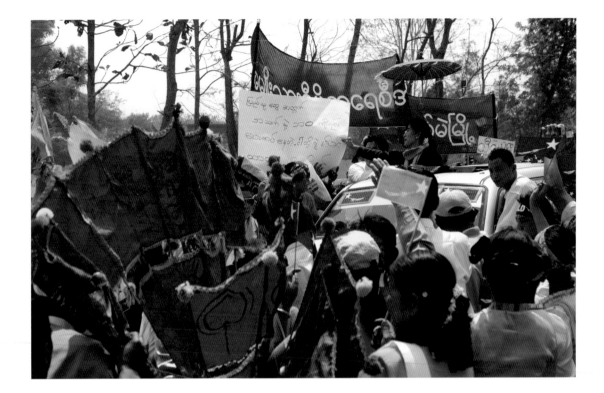

Wearing a traditional Shan costume while campaigning in Lashio on 17 March 2012, in the image above, Aung San Suu Kyi reads a banner that says: 'To our Mother Aung San Suu Kyi who is sacrificing her health and life for our country.'

The answer to the question 'When shall we get democracy?'

depends on the questions you must ask yourself:

'How much am I trying? How much am I struggling?

How much am I moving forwards?'

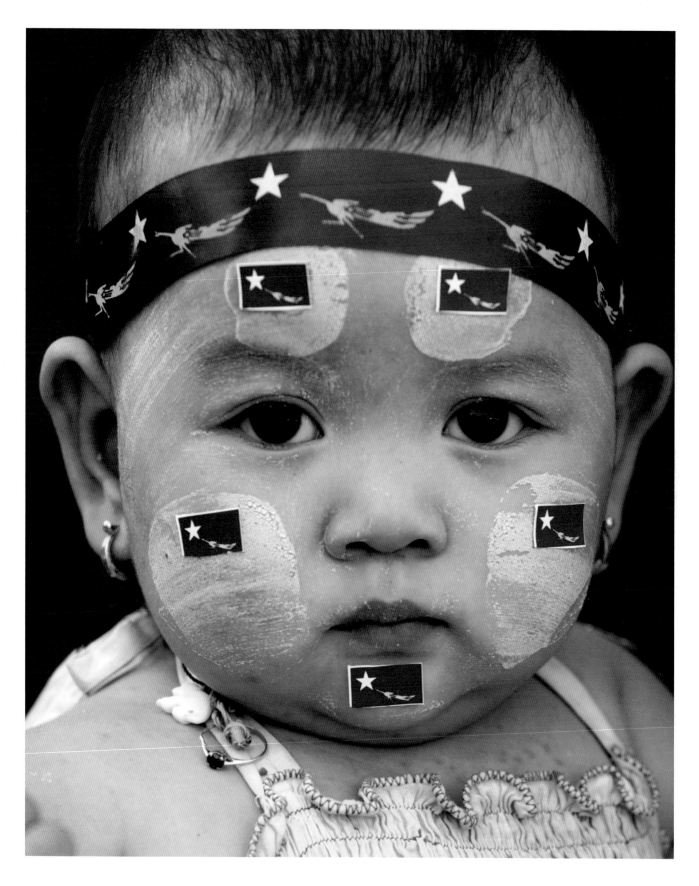

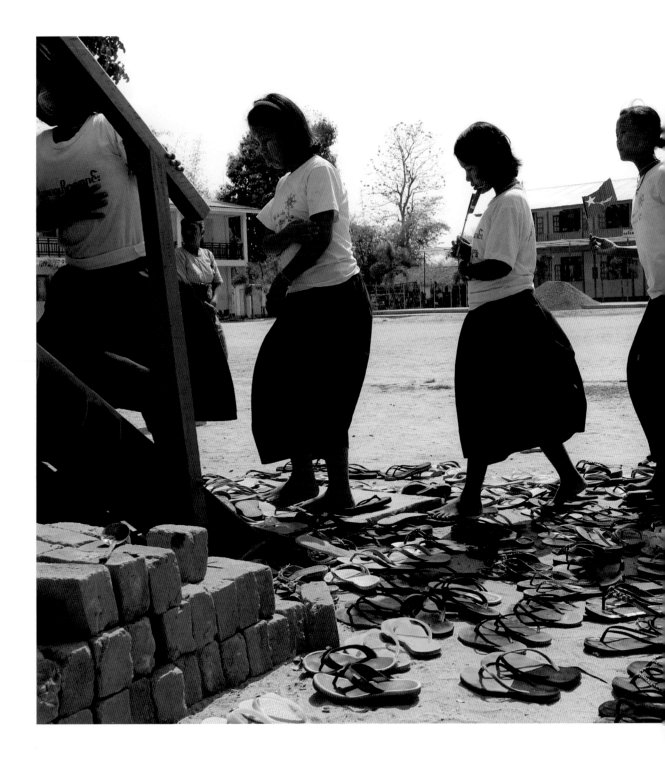

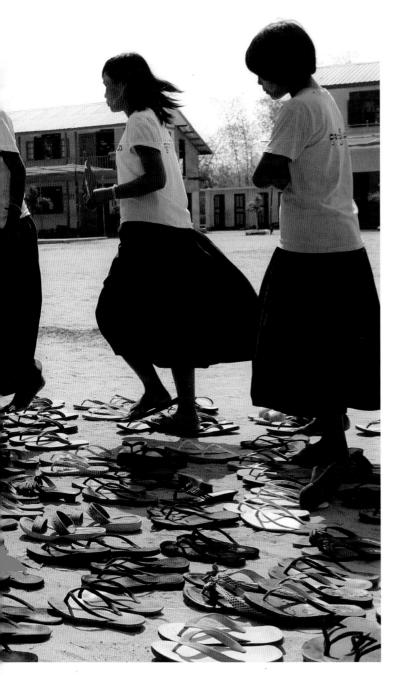

The education and empowerment of women throughout the world cannot fail to result in a more caring, tolerant, just and peaceful life for all.

Orphanage students holding NLD flags prepare to meet Aung San Suu Kyi in Kawhmu, the township where she was a candidate for the by-elections, 22 March 2012.

2012

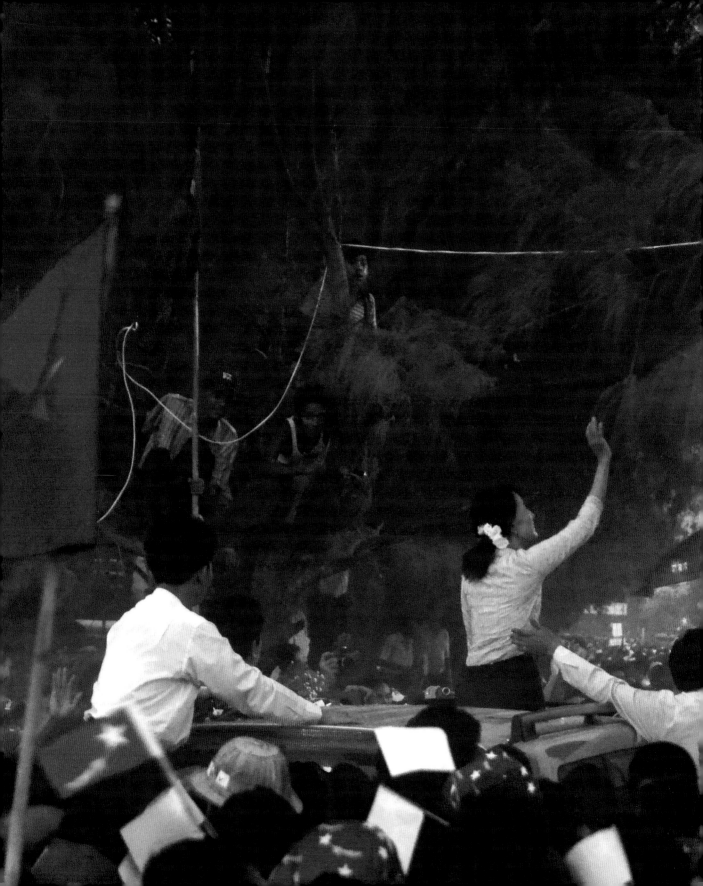

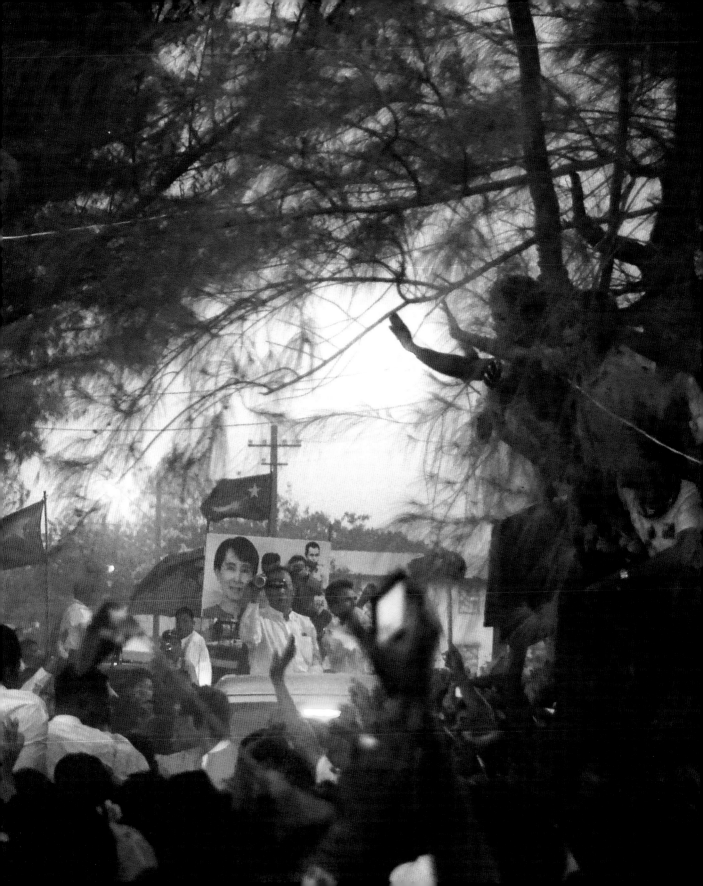

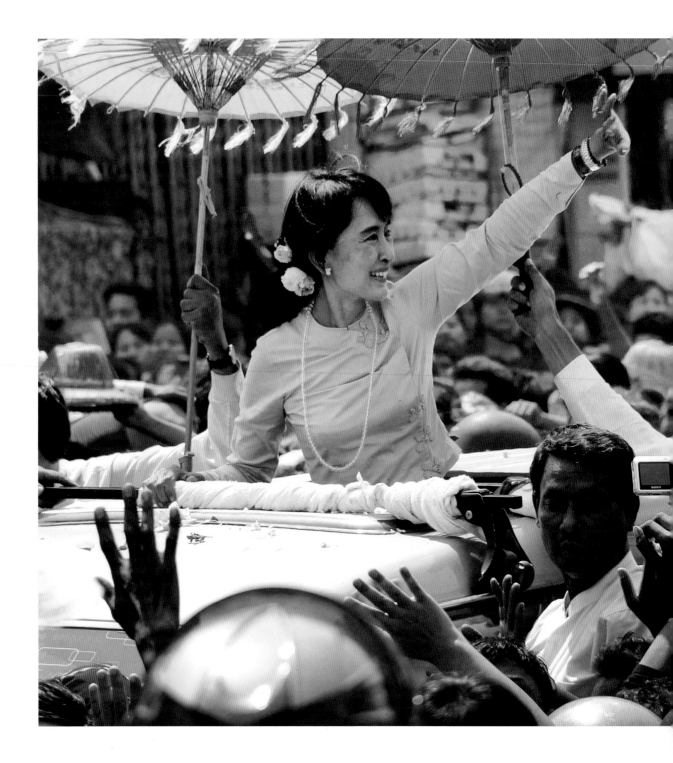

Of the sweets of adversity, and let me say that these are not numerous, I have found the sweetest, the most precious of all, is the lesson I learnt on the value of kindness. Every kindness I received, small or big, convinced me that there could never be enough of it in our world. To be kind is to respond with sensitivity and human warmth to the hopes and needs of others. Even the briefest touch of kindness can lighten a heavy heart. Kindness can change the lives of people.

2012

1980 1990 2000 2010

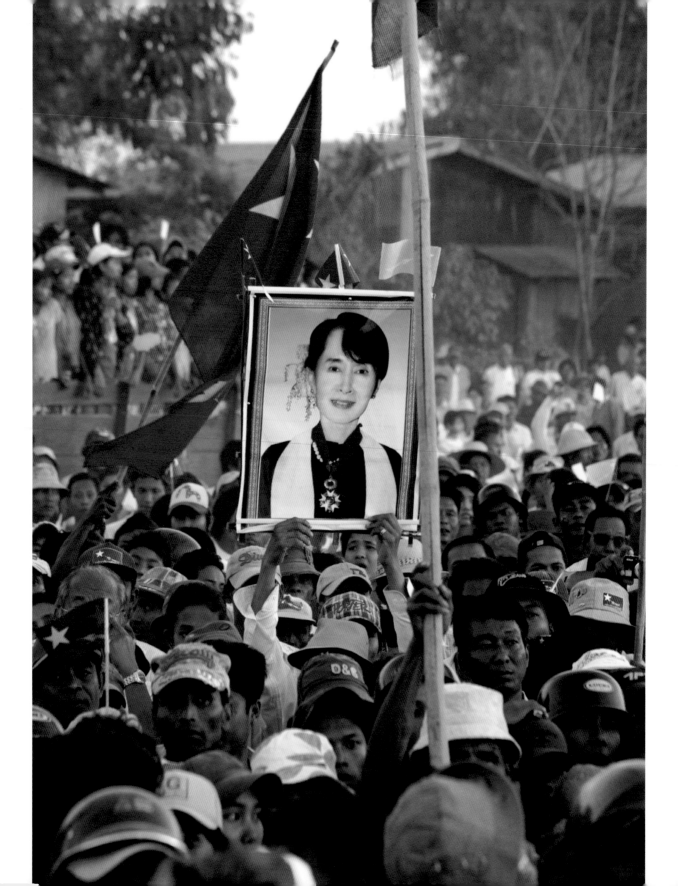

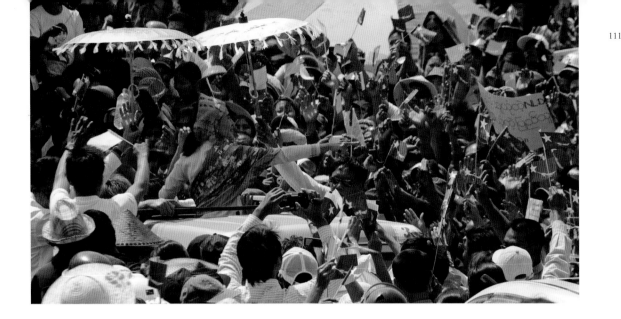

While campaigning in Kalaw, a hill town in the Shan state, Suu wore a traditional Shan dress and headband together with a Hermès shawl. This one-off, unique piece was a gift from French foreign minister Alain Juppé when he made her a Commander in the National Order of the Légion d'honneur, France's highest honour. She has also been awarded the American Congressional Gold Medal, declared an Honorary Companion of the Order of Australia and received almost one hundred and fifty other international awards and distinctions including the Jawaharlal Nehru Award for International Understanding.

She wears all the gifts that have been given to her, either expensive materials or not, when it comes from people with little means, even sometimes people who are still in jail or monks doing crochet! She will always find a way to coordinate with other clothing that she has.

Su Su Lwin, a friend of Suu's, who was also campaigning for an NLD seat

Still, she remains a very simple and warm person with a great sense of humour. Her mind is always focused and she has a genuine interest in all the people she meets. She is very positive also. What is extraordinary about her is that she does not harbour negative thoughts. If she is upset it will not take very long for her to get over it. If there is nothing you can do about something then let it be.

Ibid

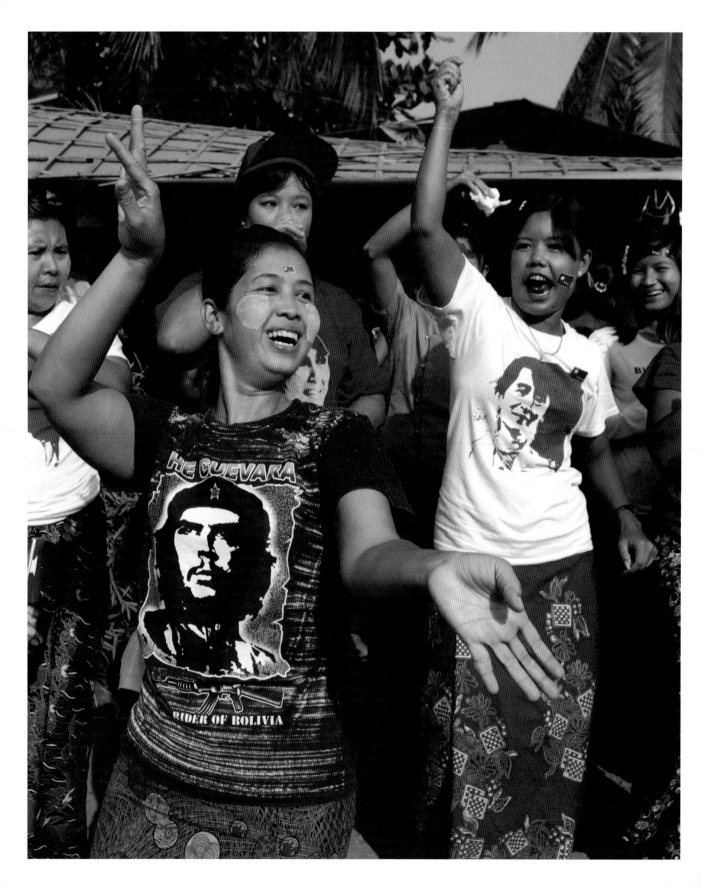

Amay [Mother] Suu,
we love you!

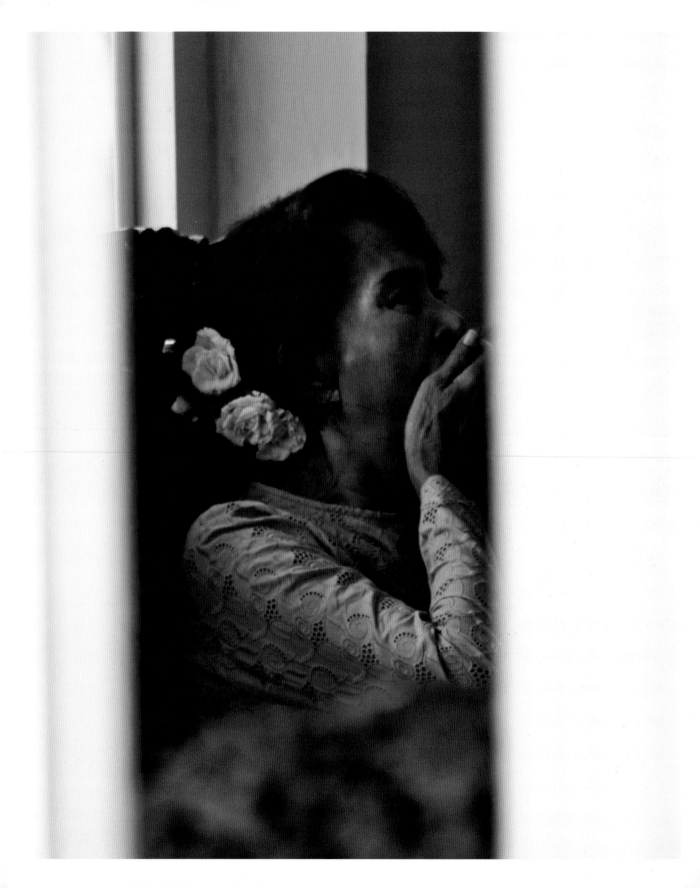

Even if she feels exhausted, she doesn't express any pain.

Tin Myo Win, Aung San Suu Kyi's personal physician

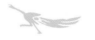

If you see her diet, you realise that she takes very good care of herself, but in fact it is her mind that keeps her healthy. Only meditation can help her withstand all this physical and mental pressure.

Ibid

On 23 March 2012, just over a week before the by-election was to take place, the government announced that it was indefinitely postponing voting in three constituencies in Kachin state, citing 'security reasons' due to ongoing fighting between government troops and armed rebels.

The by-election process was further marred with irregularities, including many cases of intimidation and instances of voter registration lists that included names of dead people. Then, as campaigning for the by-election drew to a close, temperatures reached 38 °C. Aung San Suu Kyi became ill from exhaustion and acute motion sickness. After addressing a crowd of tens of thousands in the southern city of Myeik on 24 March, she was forced to suspend her campaign and rest. But only a few days later, on 30 March, she had recovered enough to address the local and international press at her residence in Yangon.

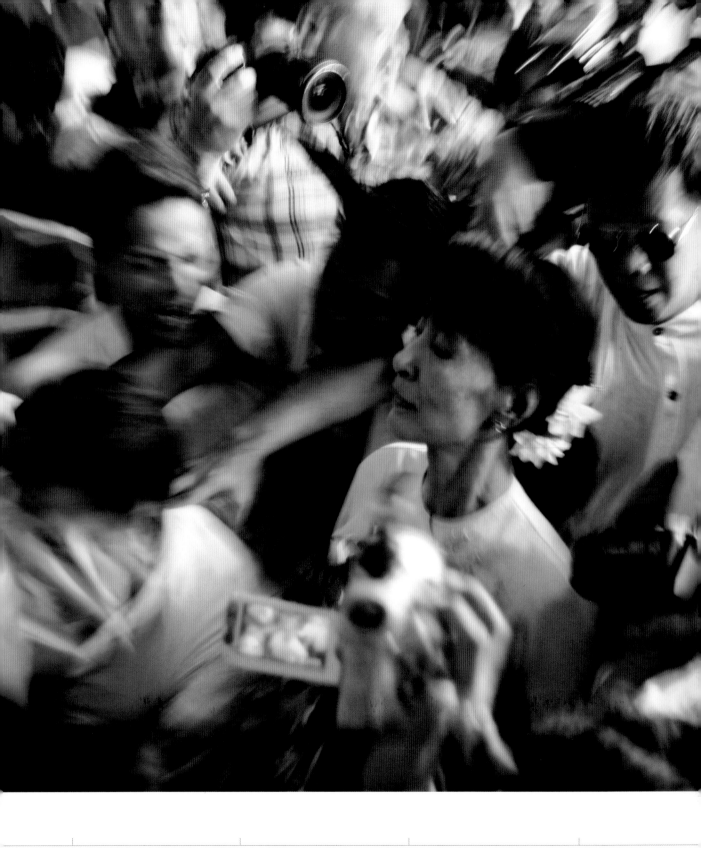

What are newspapers, radio, television and other means of mass communication all about? Some who put more emphasis on the mass than on the communication might say cynically that these are simply about making money by catering to the public taste for sensationalism and scandal. But genuine communication constitutes a lot more than mere commerce ... Experienced professional journalists ... are a boon to those of us who live in lands where there is not freedom of expression.

For decades, foreign journalists had been denied visas by the Burmese officials, but hundreds were able to fly to Yangon to cover the last few days of the by-elections. The government also relaxed its censorship, first on the Internet and then of weekly newspapers. Several daily newspapers would be allowed to start publishing the following year.

2012

1980 1990 2000 2010

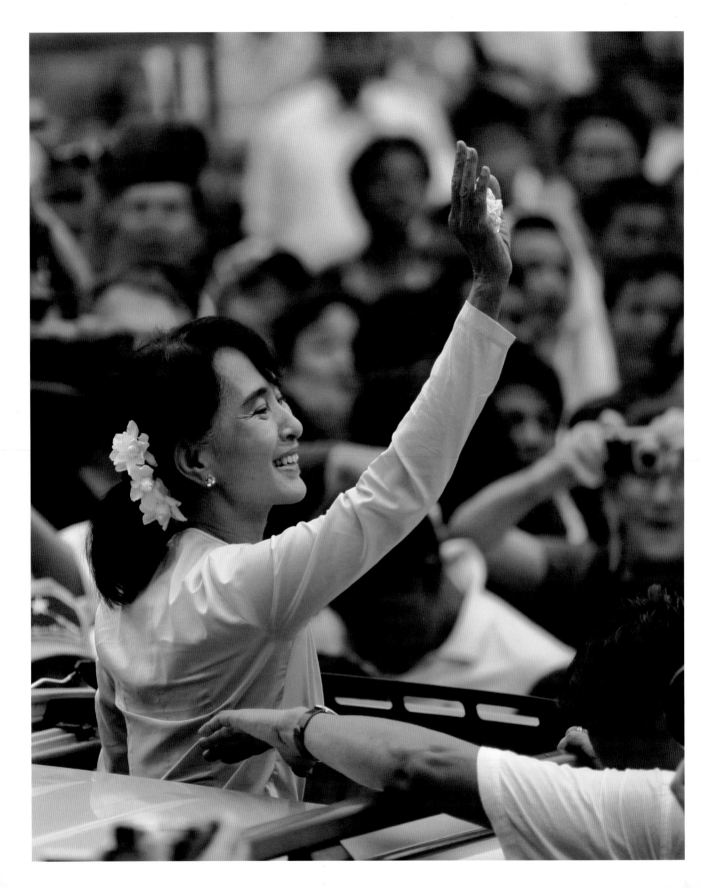

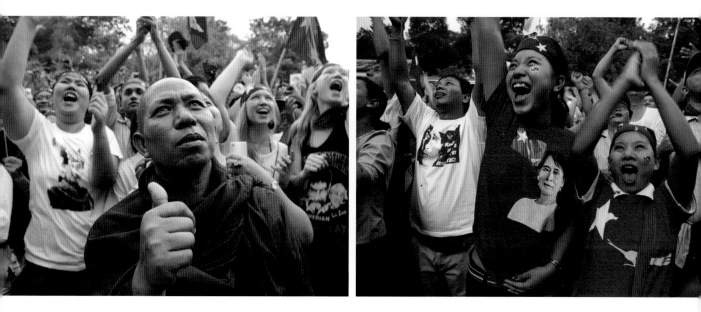

On 1 April 2012, Aung San Suu Kyi and the NLD party won forty-three of the forty-four seats they contested, sending a strong message to the government. Even in Naypyidaw, the country's new capital populated mostly by civil servants and the military, victory was conclusive. In the images above, thousands of people watch the results of the democratic election on a big screen in front of the NLD headquarters, while the image on the facing page shows Aung San Suu Kyi greeting the crowds the day after her victory.

We hope that this will be the beginning of a new era.

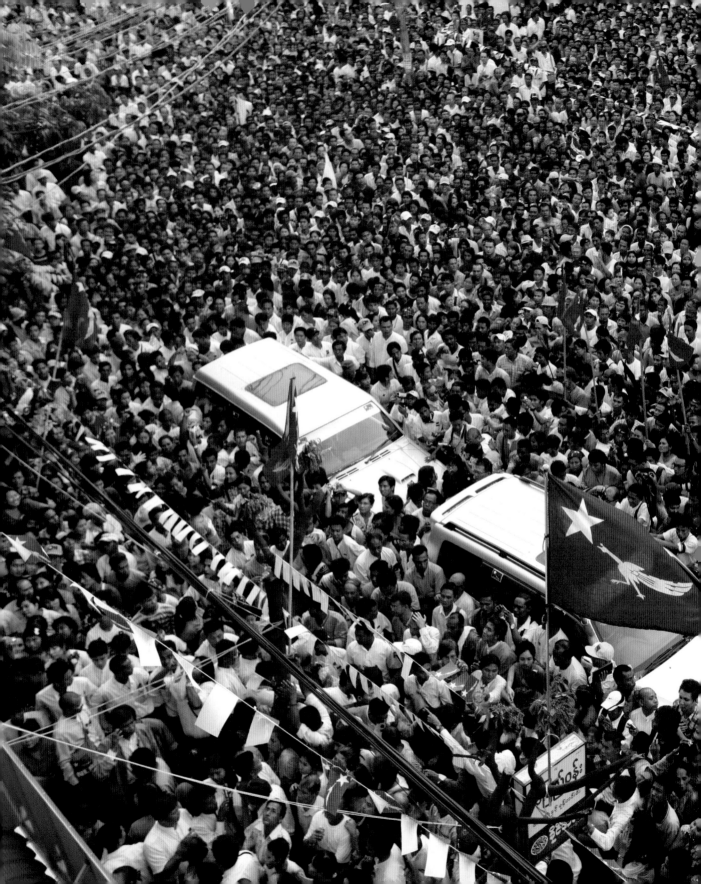

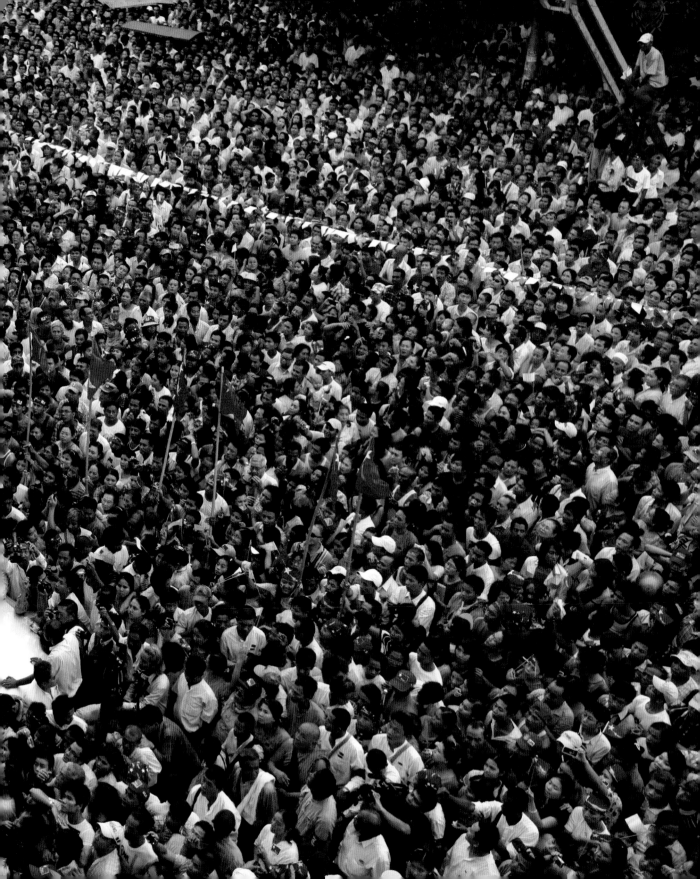

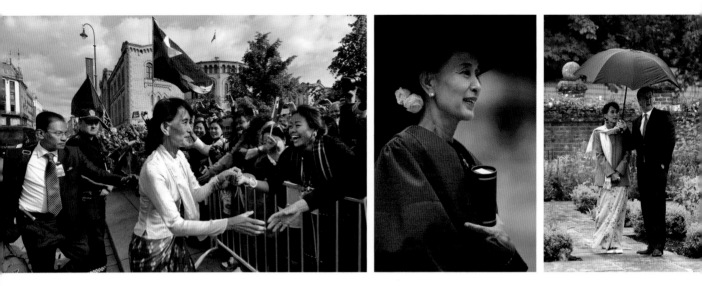

Six weeks after being elected to parliament, Aung San Suu Kyi embarked on an extended trip to Europe to visit those who had supported her during the years under house arrest. It was time to ask for investment to help steer her country out of decades of isolation and poverty. She first visited Switzerland and then travelled to Norway to collect her Nobel Peace Prize. She is pictured above left, greeting well-wishers who have gathered in the streets of Oslo. Following that she visited Ireland, England and France. In the images above she is pictured receiving an honorary doctorate from the University of Oxford, meeting British Prime Minister David Cameron and French President François Hollande, and attending a special viewing of the *Mona Lisa* at the Louvre with French culture minister Aurélie Filippetti. By coincidence, another Nobel Peace Prize laureate and international figure of inspiration, the Dalai Lama, was also visiting England. On 19 June, Aung San Suu Kyi's birthday, the two most famous exponents of non-violent political resistance since Mahatma Gandhi met privately for the first time. In Oxford, she took time off with her family and friends to celebrate her sixty-seventh birthday, and she delivered an address to both houses of parliament in London. The standing ovation she received was an honour previously accorded only to Charles de Gaulle, Nelson Mandela, Barack Obama, Pope Benedict XVI and the Queen.

I have real admiration for your courage.

The Dalai Lama

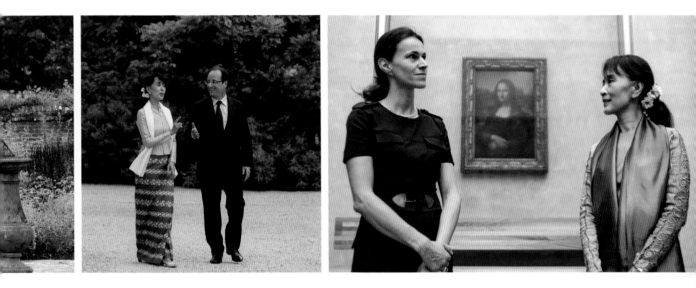

What I would like to see for our country is democracy-friendly development growth.
I would like to call for aid and investment that will strengthen the democratisation
process by promoting social and economic progress beneficial to political reform.

We want to make sure that businesses going to Burma are transparent. That way
we can find out if what they are doing is actually helping our country or harming it.

2012

1980 1990 2000 2010

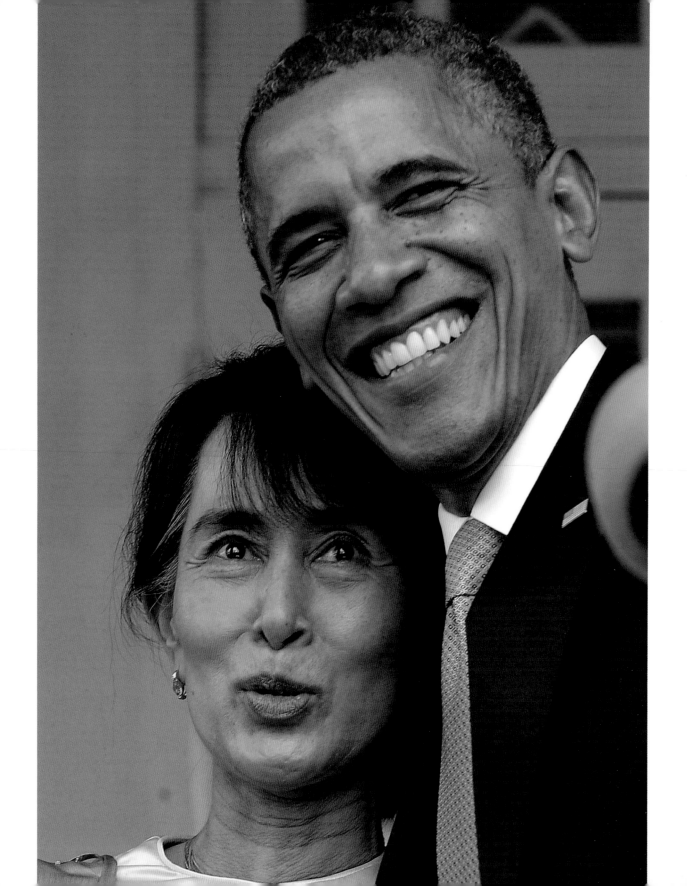

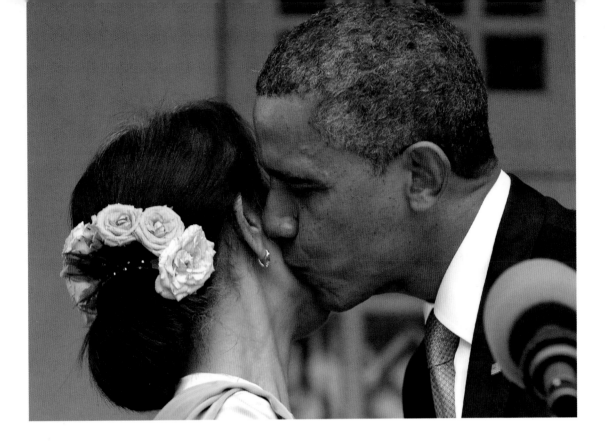

In September 2012, Aung San Suu Kyi flew for another emotional visit to the United States where she called for the lifting of American sanctions against her country. She also met President Barack Obama. Two months later, he visited her in Rangoon.

I don't think anybody's under any illusion that Burma's arrived, that they're where they need to be. On the other hand, if we waited to engage until they achieved a perfect democracy, my suspicion is we'd be waiting an awful long time.

Barack Obama, US president

The most difficult time in any transition is when we think that success is in sight. We have to be very careful that we are not lured by a mirage of success.

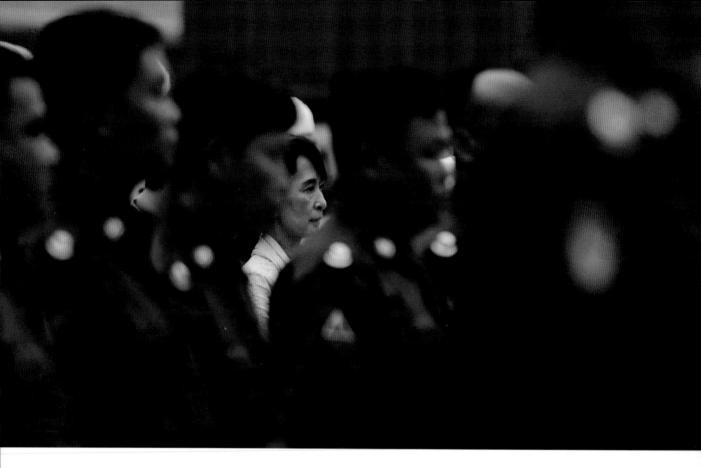

Aung San Suu Kyi's election to parliament marked a turning point in the history of Burma, as well in the life of the Nobel laureate. The images above depict her attending sessions at the lower house of parliament in 2012. After nearly a quarter century of struggle against oppression, this icon of democracy is more than ever a politician. She is willing to deal practically with challenging issues, even if it means being criticised for dealing with people who she knows have been oppressive. As she often emphasises, the hardest part is still to be done. Not only does the country have to develop, and by doing so, raise its people out of mass poverty, but the constitution also requires considerable reform and the rule of law to be implemented. In addition, ending the long-standing ethnic and religious conflicts that have plagued the country since its independence will be a formidable task. However, the success of the NLD in the April 2012 by-elections provided a foretaste of the next general elections. In 2015, enough seats will be in play that the military-backed ruling party could risk losing its power.

The legislature has turned out to be more workable than I would have imagined, in a democratic way.

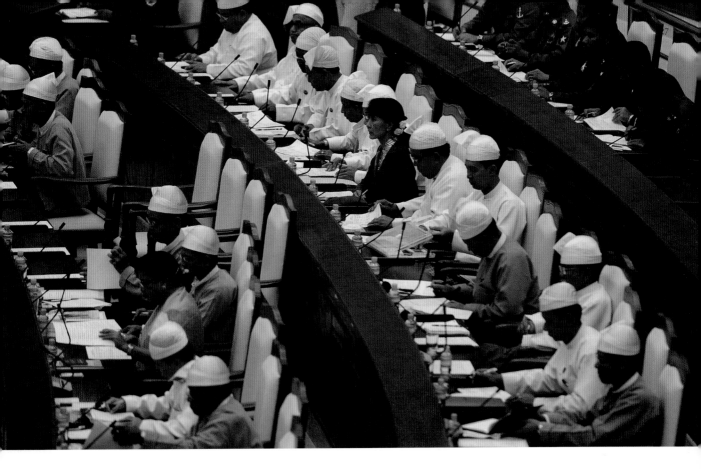

We have faith in the power to change what needs to be changed, but we are under no illusion that the transition from dictatorship to liberal democracy will be easy, or that democratic government will mean the end of all our problems. We know that our greatest challenges lie ahead of us and that our struggle to establish a stable, democratic society will continue beyond our own life span.

[Aung San Suu Kyi and Nelson Mandela] are both marked by uncommon grace, generosity of spirit and unshakable will. And they both understood something that we all have to grasp: the day they walked out of prison, the day the house arrest was ended, was not the end of the struggle. It was the beginning of a new phase. Overcoming the past, healing a wounded country, building a democracy would require moving from icon to politician.

Hillary Clinton, former US secretary of state

ACKNOWLEDGEMENTS

So many years have passed since I began to follow, step-by-step, the struggle of Aung San Suu Kyi, the National League for Democracy and the people of Burma. It has been an unbelievable privilege. They have changed my life and my perception of the world. Aung San Suu Kyi has been a model and a source of inspiration to me, as she has been for millions of people around the world. But she has also been a source of great joy and emotion. I therefore wish to express a profound gratitude to her, as well as to all those in the NLD that I have been able to meet, for their courage and kindness, especially U Win Tin, U Win Htein, U Nyan Win, U Naing Naing, Daw Su Su Lwin, U Htin Kyaw and Phyu Phyu Tin, as well as Khun Thar Myint, Dr Tin Mar Aung, Ko Ni, Maung Thar Myint, Htay Htay Win, Nay Chi Win, U Kyi Toe, Ko Baw Gyi, Zaw Min Oo, Kyaw Thura Ko Ko, Kyaw San, Hlaing Myo Htwe, Shafee, Ma Ohnmar and Soe Myat Thu.

Along with Aung Pyae, Pyay Kyaw Myint, Minzayar Oo, Lynn Bo Bo and Soe Than Win, the Burmese photographers who contributed to this work, I would particularly like to thank Thierry Mathou, French ambassador to Myanmar; Alexandre de Lesseps; the teams at the Institut Français de Birmanie; the Danish NGO International Media Support; Canon Myanmar, in particular Alvin Law; Forever Group and FMI Group for their unwavering support of the Yangon Photo Festival and associated training courses.

I have thoroughly enjoyed working with Jo Garden, Rachel Clare and the team at PQ Blackwell during the editing of this book and with Helene Dehmer on the design. May San San, Kim Aris and Malavika Karlekar kindly helped in identifying the archive photographs, as did Fanny Steeg. Thank you to Stuart Isett and Platon for allowing us to use their beautiful photographs.

And finally, thank you to the following people who, at one time or another, have helped us: Mélanie Agron, Tun Tun Aye, Olivier Binst, Anne-Marie-Bourgeois, Vincent Brossel, Christophe Cachera, Thomas Dandois, Christopher Davy, Sylvie de Guyon, Anne Demeneix, Marc Eberle, Thierry Falise, Hervé and Thuzar Fléjo, Nicolas Havette, Paula Holme, Hla Hla Htay, Isabelle Jendron, Oktavia Jonsdottir, Mayco Naing, Nay Zaw Naing, Virginie Raisson, Jean-Christophe Victor, Khin Maung Win and Zhao Qiu Ying.

Christophe Loviny

PHOTOGRAPHIC SOURCES AND PERMISSIONS

Every effort has been made to trace the copyright holders of the images reproduced in this book and the publisher apologises for any unintentional omission. We would be pleased to hear from any not acknowledged here and undertake to make all reasonable efforts to include the appropriate acknowledgement in any subsequent editions.

Front endpaper: Pyay Kyaw Myint; p. 4: Platon; p. 6: Maung Maung Gyi/Myoma Studio; p. 8: (left) Aung San Suu Kyi private collection, (right) Maung Maung Gyi/Myoma Studio; p. 9: Maung Maung Gyi/Myoma Studio; pp. 11, 12, 13 and 14: Aung San Suu Kyi private collection; pp. 16–17: Malavika Karlekar; p. 18: Aung San Suu Kyi private collection; p. 19: Getty Images/Aris Family Collection; pp. 20–21, 23: Aung San Suu Kyi private collection; p. 24: Getty Images/Aris Family Collection; p. 25: Aung San Suu Kyi private collection; pp. 26–27, 28: Getty Images/Aris Family Collection; pp. 29: Aung San Suu Kyi private collection; pp. 30–31: Getty Images/Aris Family Collection; pp. 32–33: Aung San Suu Kyi private collection; p. 34: Getty Images/Aris Family Collection; pp. 36, 37: Aung San Suu Kyi private collection; p. 38: Getty Images/Aris Family Collection; pp. 40, 41: Getty Images/Sandro Tucci; p. 42: (top) Aung San Suu Kyi private collection, (bottom left and right) AFP PHOTO; p. 45: AFP PHOTO; pp. 46–47, 48, 49, 50, 51, 53, 54, 58: Aung San Suu Kyi private collection; pp. 61, 62, 64–65: Christophe Loviny; pp. 66, 67: Stuart Isett; p. 68: Aung San Suu Kyi private collection; p. 70: Photographer unknown; p. 73: Aung San Suu Kyi private collection; p. 74: (left) Stuart Isett, (right) AFP PHOTO/Khin Maung Win; p. 76: (top and bottom right) Reuters (bottom left) Image Forum; pp. 78–79: AFP PHOTO/Soe Than Win; p. 80: (left) Lynn Bo Bo, (right) AFP PHOTO/Soe Than Win; p. 81: Lynn Bo Bo; p. 82: Image Forum/Myanmar News Agency; pp. 84–85, 87: Lynn Bo Bo; pp. 88–89: Aung Pyae; p. 90: AFP PHOTO/Soe Than Win; p. 93: Lynn Bo Bo; pp. 94–95: Pyay Kyaw Myint; p. 96: (top) Aung Pyae (bottom left and bottom right) Minzayar; pp. 98–99: Christophe Loviny; p. 100: Minzayar; p. 101: Aung Pyae; pp. 102, 103: Christophe Loviny; pp. 104–105: Pyay Kyaw Myint; pp. 106–107: Aung Pyae; pp. 108–109: Pyay Kyaw Myint; pp. 110, 111, 112: Christophe Loviny; p. 113: (left) Aung Pyae, (right) Christophe Loviny; pp. 114, 116–17, 118: Minzayar; p. 119: Christophe Loviny; pp. 120–21: Minzayar; p. 122: (left) Nobel Foundation/Ken Opprann, (centre) AFP PHOTO/Ben Stansall, (right) AFP PHOTO/Adrian Dennis; p. 123: (left) AFP PHOTO/Bertrand Langlois, (right) AFP PHOTO/Fred Dufour; pp. 124, 125: AFP PHOTO/Jewel Samad; pp. 126, 127: AFP PHOTO/Soe Than Win; p. 128: Christophe Loviny; back endpaper: Aung Pyae.

LITERARY PERMISSIONS

Produced and originated by PQ Blackwell Limited
116 Symonds Street, Auckland 1010, New Zealand
www.pqblackwell.com

An SBS Book

First edition published in 2013 by Hardie Grant Books

Hardie Grant Books (Australia)
Ground Floor, Building 1
658 Church Street
Richmond, Victoria 3121
www.hardiegrant.com.au

Hardie Grant Books (UK)
Dudley House, North Suite
34–35 Southampton Street
London WC2E 7HF
www.hardiegrant.co.uk

Concept and text © 2013 Christophe Loviny
Design and compilation © 2013 PQ Blackwell

The credits in *Photographic Sources and Permissions,
Literary Permissions* and elsewhere serve as an extension
of the copyright page.

A Cataloguing-in-Publication entry is available from the
catalogue of the National Library of Australia at www.nla.gov.au
Aung San Suu Kyi – A Portrait in Words and Pictures
978 1 74270 651 1

Printed by 1010 Printing International Limited, China

PQ Blackwell
Publisher: Geoff Blackwell
Editor-in-Chief: Ruth Hobday
Editor: Jo Garden
Additional editorial and research: Rachel Clare
Book design: Helene Dehmer

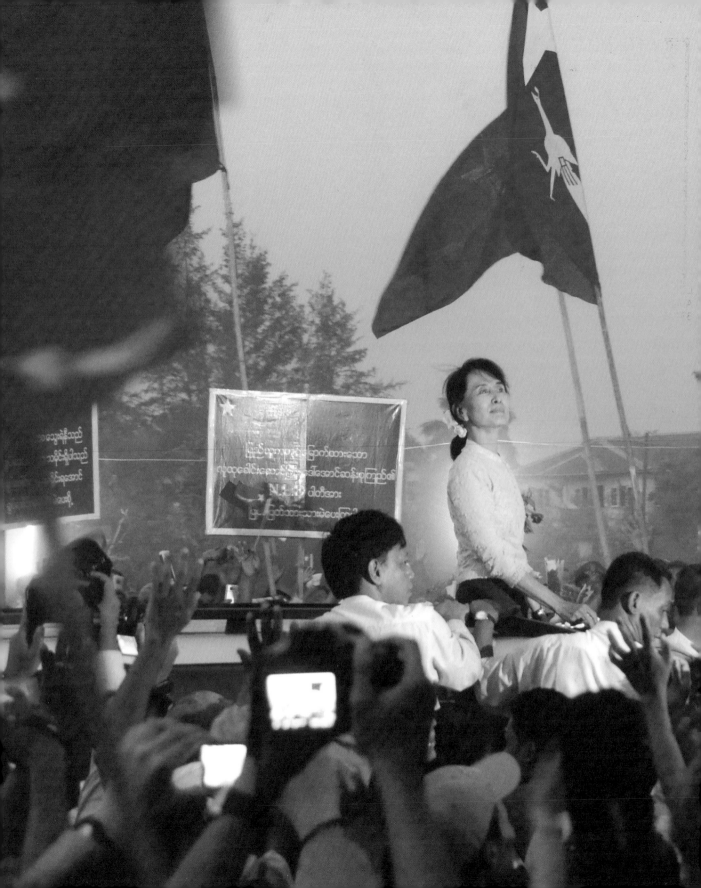